Lighthouses

Willie Ortiz

Copyright © 2016 Willie Ortiz

All rights reserved.

ISBN: 1533513961
ISBN-13:9781533513960

ACKNOWLEDGMENTS

I would like to thank my wife Sharon Ortiz for her constant support in everything I do and your never-ending love for me.
To my wonderful parents who always support me in everything I do and taught me anything is possible.
To my in-laws for all their support and encouragement.

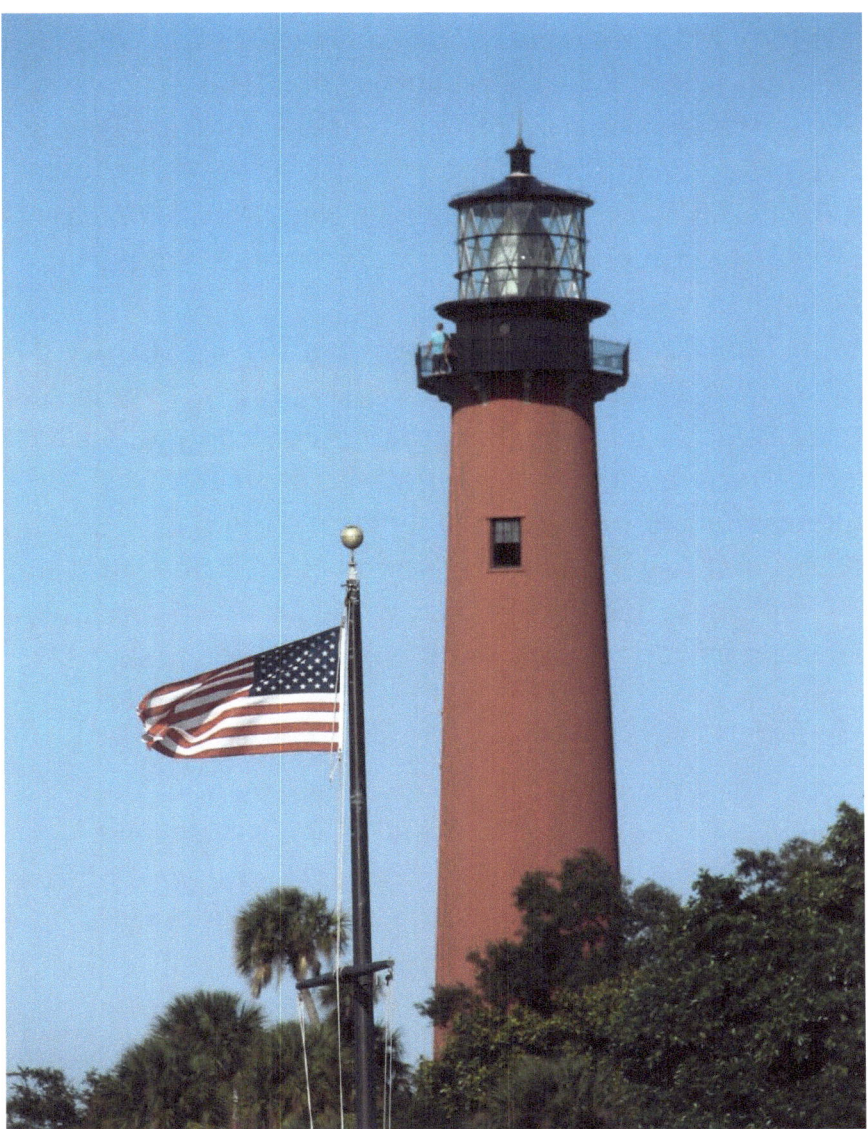

Above: Jupiter Inlet Lighthouse, Jupiter Florida

The history of lighthouses dates back more than 2000 years. the ancient Greeks and Romans had lighthouses. One of the Seven Wonders of the Ancient World was a lighthouse—the famous Pharos of Alexandria, Egypt.

It is the first one that is recorded in history and was built about 280 BC. Those records tell us that it was the tallest one ever built—450 ft. (comparable to a 45-story skyscraper) and used an open fire at the top as a source of light. This fantastic structure survived for 1500 years until it was completely destroyed by an earthquake in the 14th century.

Important Dates in United States Lighthouse History

1716 - First lighthouse built in the United States was Boston Lighthouse built on Little Brewster Island. This lighthouse was destroyed during the Revolutionary War and was rebuilt in 1783 and still stands today.

1719 - First Fog Signal was a cannon placed near Boston Lighthouse. When there was fog, the cannon would be constantly fired to warn ships away from the rocky ledges.

1789 - The United States Lighthouse Establishment was created and operated under the Department of the Treasury. This was the Ninth Law as well as the first Public Works Act passed by Congress on August 7 of that year. Because of this, every August 7th is National Lighthouse Day. This law also passed ownership and responsibility of all lighthouses to the federal government. Prior to that the lighthouses were built and owned by the individual states or territories.

1791 - The first lighthouse completed under the ownership of the federal government was completed at Portland Head Light in Maine. Construction had been actually started and funded by the State of Massachusetts.

1792 - Cape Henry Lighthouse, Virginia, became the first lighthouse built and completed by the Federal Government.

1793 - First lightship* approved by President George Washington; it would be used on the Delaware River.

1818 - First lighthouses on the Great Lakes were established at Buffalo, NY on Lake Erie and Presque Isle, PA, also on Lake Erie.

1820 - First use of bells as a fog signal device was at West Quoddy Head Light in Maine.

1822 - The French physicist, Augustin Fresnel, beginning this year, "revolutionized lighthouse practice by developing a built-up annular lens comprised of a central spherical lens surrounded by rings of glass prisms, the central portions of which refract and the outer portions both reflect and refract in the desired direction the light from a single lamp placed at the central focus (inside the middle of the light)."

1831 - First lighthouse in the United States to operate using natural gas was the lighthouse at Barcelona (Portland Harbor), NY on the south shore of Lake Erie.

1837 - The first lightship on the Great Lakes began operation. It was stationed at the junction of Lakes Huron and Michigan.

1840 - The First Lighthouse Tender of the U.S. Lighthouse Service started service. It was the former U.S. Revenue Service Cutter RUSH. Prior to this date other government vessels and private vessels were used to maintain buoys and supply lighthouses. This practice continued until the Lighthouse Service had enough ships to perform the job on their own.

*Navigational aid, where a ship is anchored serving as a lighthouse, when a permanent structure is not feasible.

1841 - The first Fresnel lens used in a United States lighthouse was imported from France and installed in Navesink Lighthouse in New Jersey.

1850 - First screw-pile lighthouse was constructed in the United States at Brandywine Shoal.

First iron lighthouse in the United States was built in a position directly exposed to the sweep of the ocean was completed at Minot's Ledge, MA. It was destroyed in a storm the following year, killing two of its keepers.

1852 - The Lighthouse Board was created to oversee all of the lighthouses in the United States.

1854 - First lighthouse on the Pacific coast was completed on Alcatraz Island in San Francisco Bay.

1860 - The first stone lighthouse built in the ocean in the United States is completed at Minot's Ledge, MA. Construction started in 1855 and it took five years to complete. It was one of the great engineering building accomplishments of its time.

1869 - First steam-powered fog signals in the United States were installed at Maine lighthouses at West Quoddy Head and Cape Elizabeth.

First Flag- The first use of the U.S. Lighthouse Service flag was a red, white and blue pennant with a lighthouse.

1871 - Duxbury Pier Light in Plymouth Harbor, Massachusetts became the first caisson lighthouse built in the United States.

1877 - Kerosene became the primary fuel used to power the lighthouses. Prior to that various illuminants were

used such as sperm oil, colza or rapeseed oil, and lard oil.

1884 - First uniforms were introduced for male lighthouse keepers as well as for masters, mates and engineers of lightships and tenders. The wearing of both dress and fatigue uniforms was mandatory. Female lighthouse keepers were not required to wear a uniform.
1886 - The first use of electricity for lighthouse purposes in the United States by the placing of an arc of light in the Statue of Liberty in New York.
1898 - All seacoast lighthouses were turned off for the first time in history as a precaution during the Spanish-American War.
First wireless message sent from ship to shore was from the San Francisco Lightship.
1904 - First ship with radio communications was the Nantucket Lightship. It was the first U.S. vessel to so be equipped.
1910 - Name Change. An act of Congress abolished the Lighthouse Board and created the Bureau of Lighthouses to be in charge of all lighthouses, thus changing its operating name from the United States Lighthouse Establishment (USLHE) to the United States Lighthouse Service (USHLS). Under the new law the first Commissioner of Lighthouses, George R. Putnam, took office.
1916 - First powerboats for lighthouses were designed, built and tested at Great Lakes lighthouses.

1917 - World War I saw the transfer of most lighthouse tenders, lightships and primary lighthouses to War Department and U.S. Navy until the end of the war. An Act of Congress appropriated $300,000 to install telephones and telephone lines to all Coast Guard Stations and the most important lighthouses.

1918 - First American lightship sunk by an enemy was the Diamond Shoals Lightship off the Outer Banks of North Carolina. All crewmembers survived.

1926 - The Lighthouse Airways Division was established by U.S. Lighthouse Service; its work covering the examination of airways and landing fields and the erection of aids to air navigation. Instead of have beams of light that pointed out to sea, towers were built with beams of light pointed into the sky.

1928 - First radio beacon in the United States, automatic in operation, was completed and put into commission at Cape Henry Lighthouse, Virginia.

1933 - The U.S. Lighthouse Service Airways Division was transferred to Department of Commerce and put under the control of the Assistant Secretary for Aeronautics.

1934 - Lightship sunk - The Lightship No. 117, Nantucket, occupying the Nantucket Shoals Station in a dense fog, was struck by the HMS OLYMPIC (sister ship of the TITANIC) and cut in two and sunk almost immediately with the loss of seven crewmembers.

1936 -"Most decentralized branch of government", so stated a report which indicated that less than one percent of the approximate 5000 total employees of the U.S. Lighthouse Service were located away from the seat of government in Washington D.C.

1937 - Trunks replacing tenders - With the ever-improving road system in the United States, the Lighthouse Service started using motor trucks to supply some lighthouses and other easy to reach shoreline aids to navigation.

1939 - (July, 1) The United States Lighthouse Service is abolished and merged into the United States Coast Guard. This was the first time in the history of the United States Government that a military branch took over another branch of the government. At that time there were 5,355 employees of the U.S. Lighthouse Service, consisting of 4,119 full-time and 1,156 part-time employees, which included 1,170 light-keepers and assistants, 56 light attendants, 1,195 officers and crews of lightships and tenders; 113 Bureau officers, engineers and draftsmen as well as district superintendents, technical assistants, 226 clerks, messengers, janitors, office laborers, 157 depot keepers and assistants, including watchmen and laborers and 482 field-force employees in construction and repair work. There were 30,000 aids to navigation, which included lightships and lighthouses, 64 lighthouse service tenders, hundreds of other types of crafts, numerous trucks, automobiles and trailers, 30 lighthouse digests, and 17 district offices.

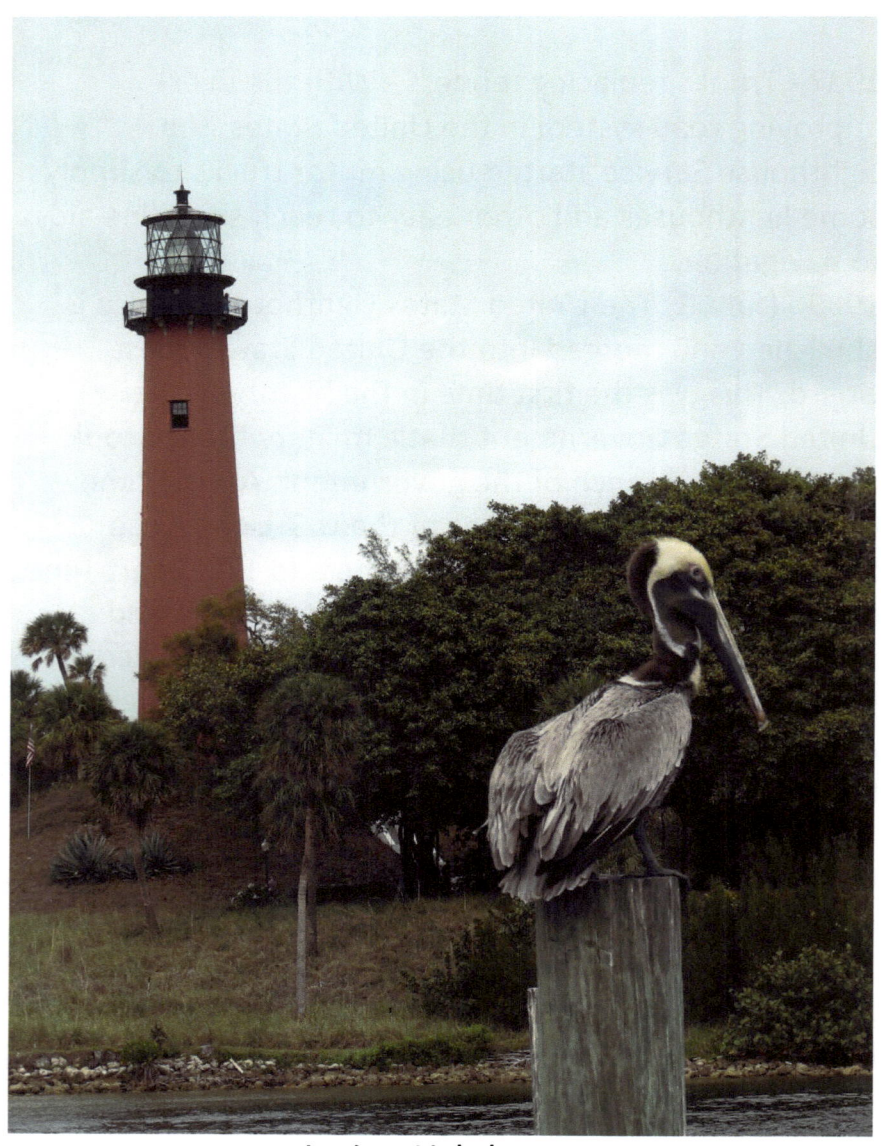

Jupiter Lighthouse

Early U.S. lights commonly used a shallow container of whale oil (Sperm whale oil), in which several lighted, solid, wicks floated. This was known as a "spider lamp". Its range of visibility was quite poor and it emitted quite a bit of smoke and fumes.

However, fish, lard, and rapeseed oils were also used throughout the 1800s. During the earlier day's natural gas was experimented with in lighthouses. It did not catch on widely. The Jones Point Lighthouse a small river lighthouse located on the Potomac River in Alexandria, Virginia. used underground lines which proved to be problematic and unreliable. Towards the end of the 19th century as technology improved, vaporized kerosene was used to fuel almost all of the lighthouse lamps.

Its interesting to note that for decades preceding its adoption many experts considered kerosene too volatile for safe usage. Today, it is the fuel most people associate with lighthouses. In the early 20th century most lamps were converted to use acetylene before they were automated. Electricity was implemented after that. The choice of fuel and the lamp used was pretty much independent from the lenses until the adoption of electric lamps. The light emitted by many types of electric bulbs was not optimal for Fresnel lenses. Because of this, lights still used as primary aids to navigation tend to have had their lenses replaced.

The effectiveness of lighthouse beacons advanced forward in 1821 when a young French engineer named Augustin-Jean Fresnel developed a new magnifying lens comprised of a series of crystal prisms. The prisms focus the light source into a powerful beam that was many times more visible than those produced by earlier lens designs. Use of the Fresnel lens quickly spread through Europe, but their adoption in the U.S. and on the Chesapeake Bay was delayed by the inadequacies of the 5th Auditor's administration. It was not until the system overhaul of 1852 that Fresnel lenses began appearing in U.S. Lighthouses.

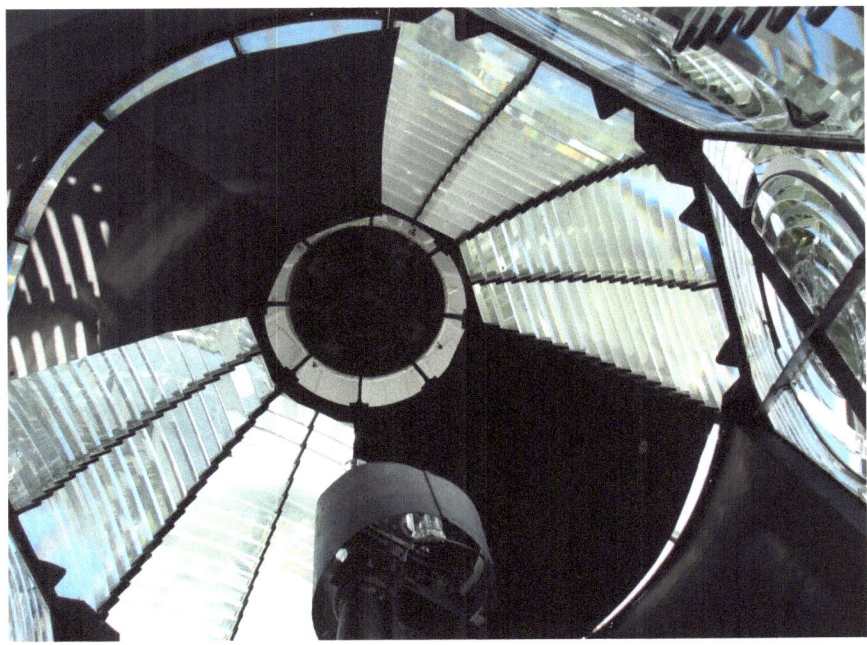

Willie Ortiz

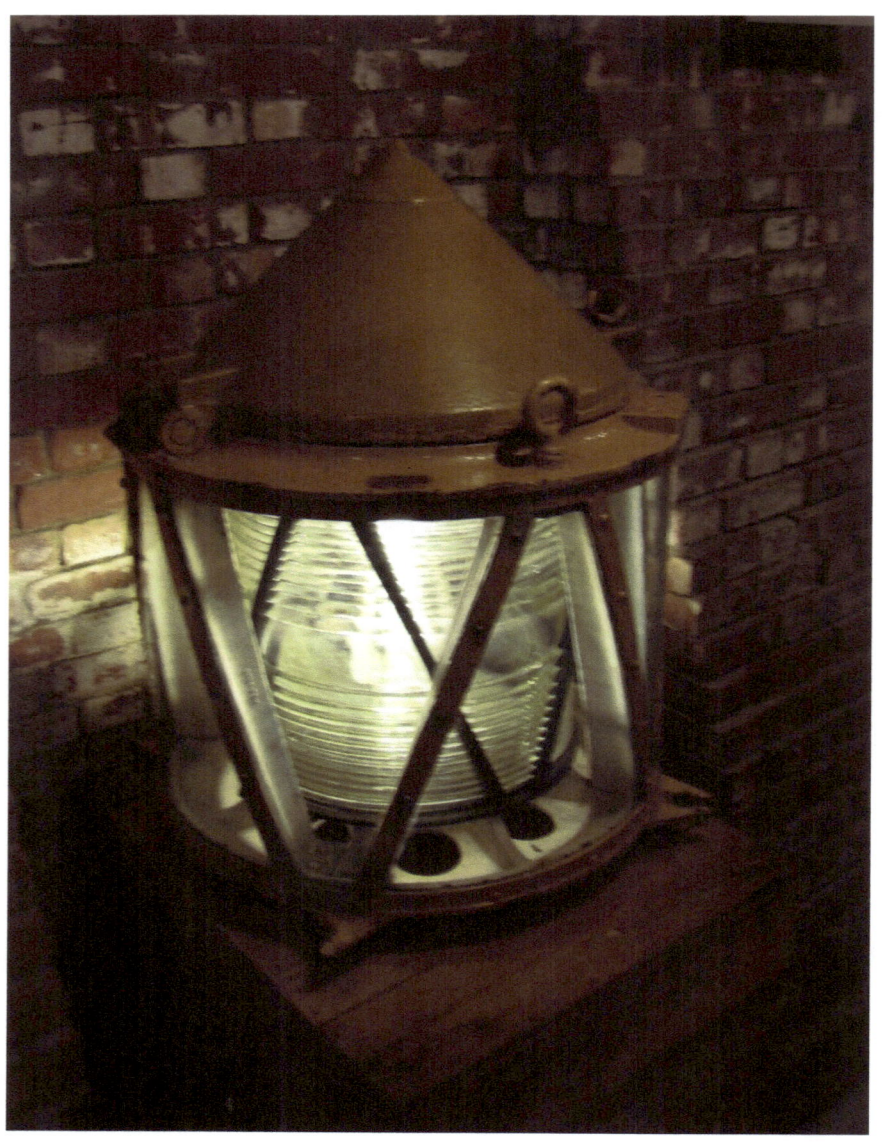

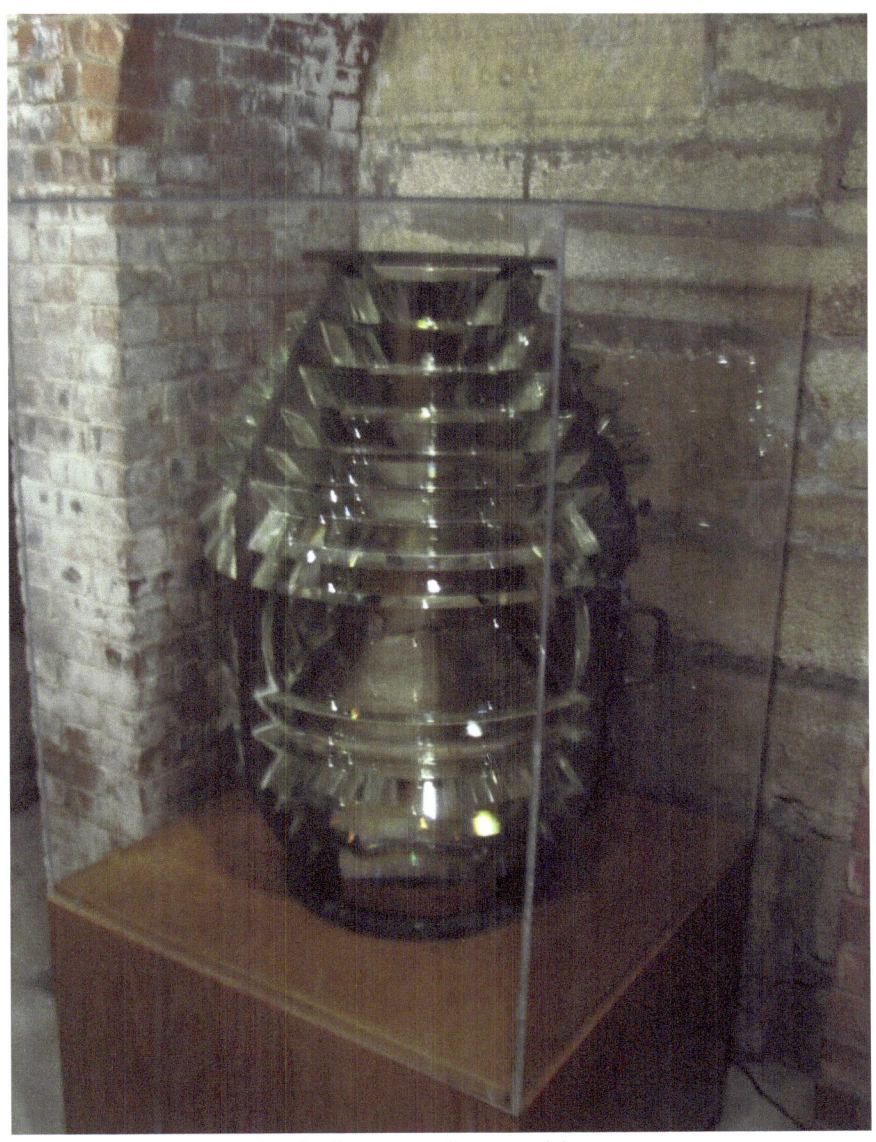

Third order Fresnel lens

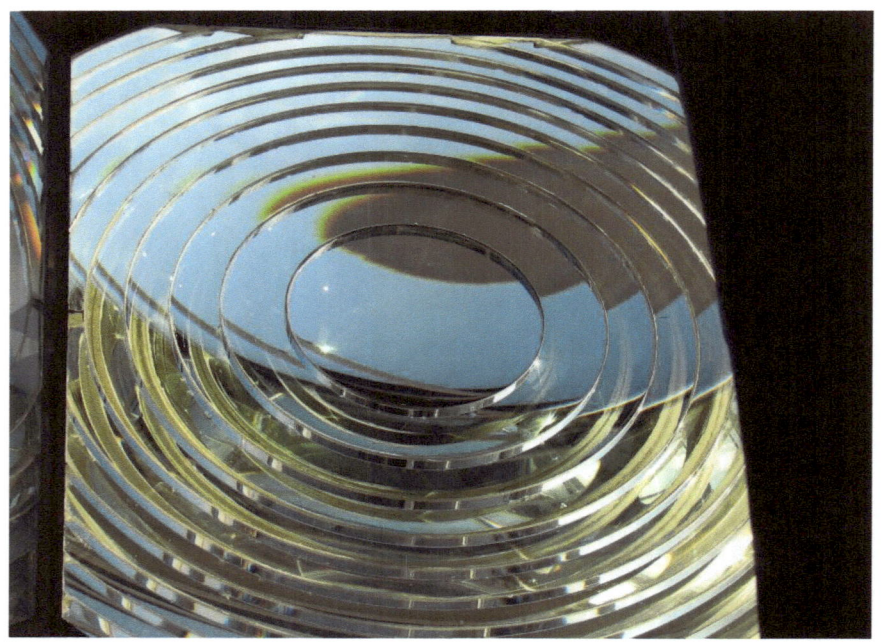

Fresnel lenses are divided into "orders" numbered one through six. A first order Fresnel lens is the biggest and the type used by large ocean lighthouses. They stand approximately 8 feet tall, with an inside diameter of 6 feet, can weigh over 5 tons, and they may have a range of 18 to 20 miles. A sixth order lens is reasonably small - about 17 inches tall with an inside diameter of 11 1/4". It can weigh up to 200 pounds and has a range of 1 to 3 miles. Most of the Chesapeake Bay lighthouses constructed in the mid-1800s were originally fitted with fifth order Fresnel lenses. In the later part of the 1800s these were usually upgraded to fourth order lenses (which stand about 2 1/2 feet tall and have an inside diameter of about 20").

Lighthouse

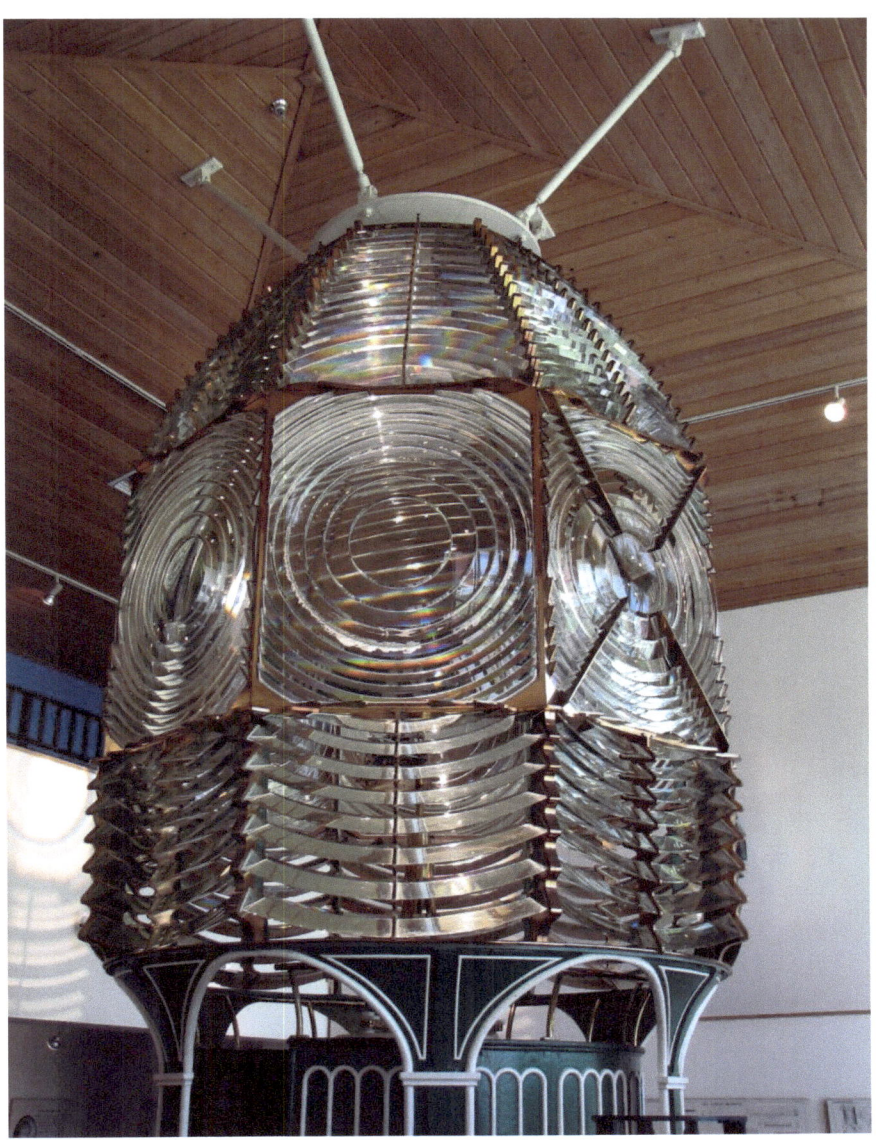

Second order lens

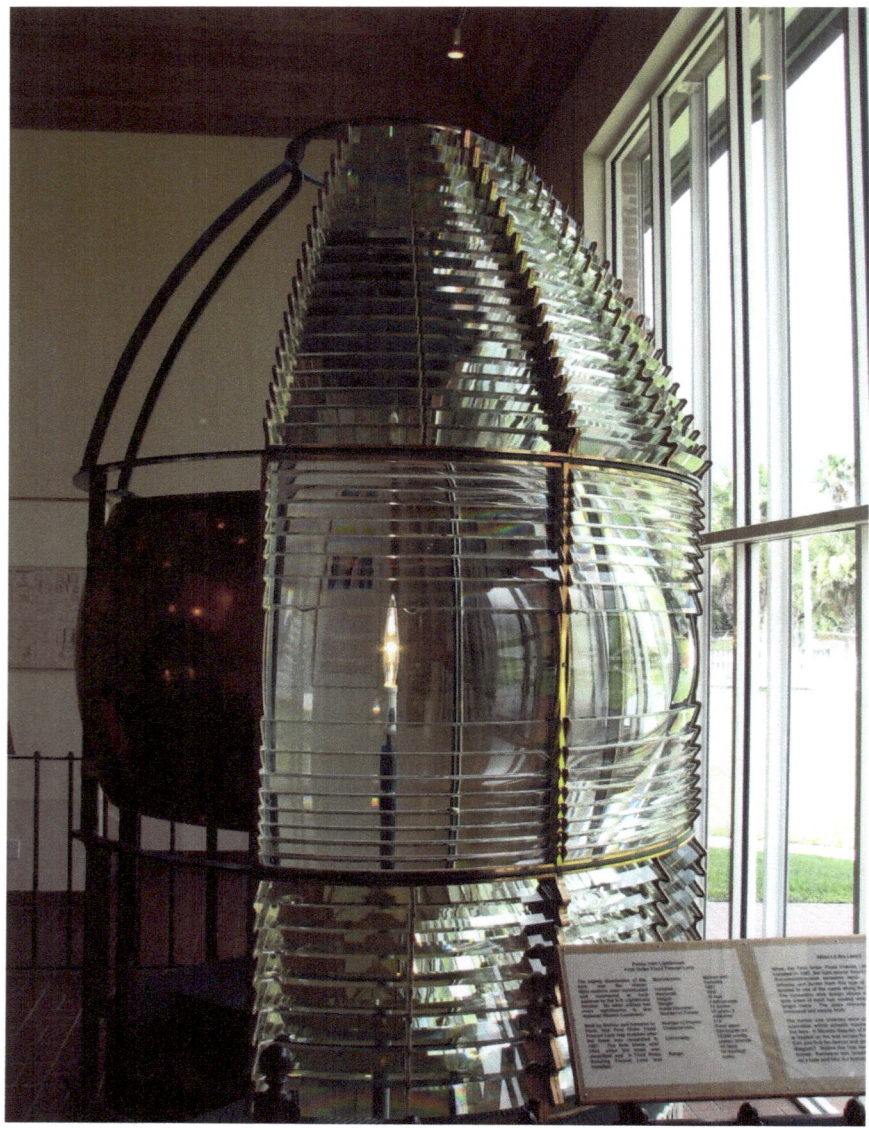

First order Fresnel Lens

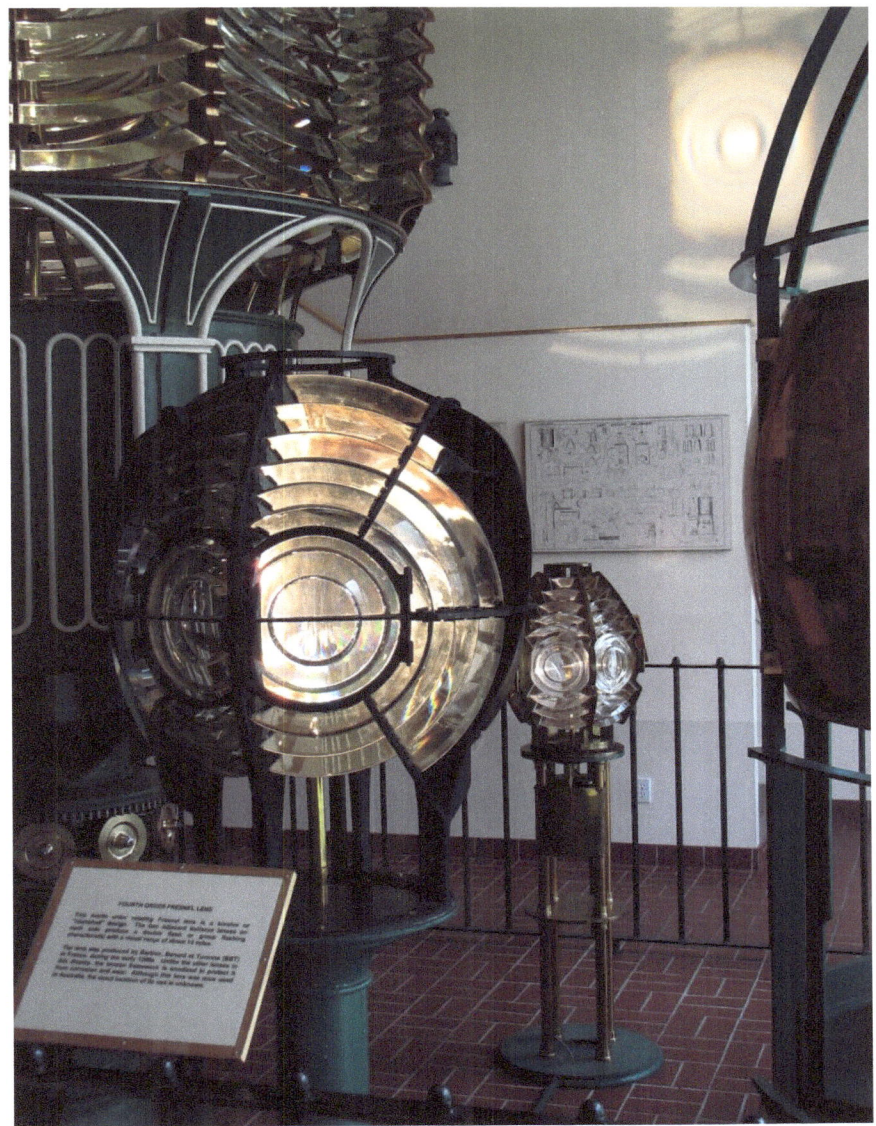

On the forward left is the Fourth order Fresnel lens

Lenses on display at the Ponce de leon lighthouse in Florida.

Willie Ortiz

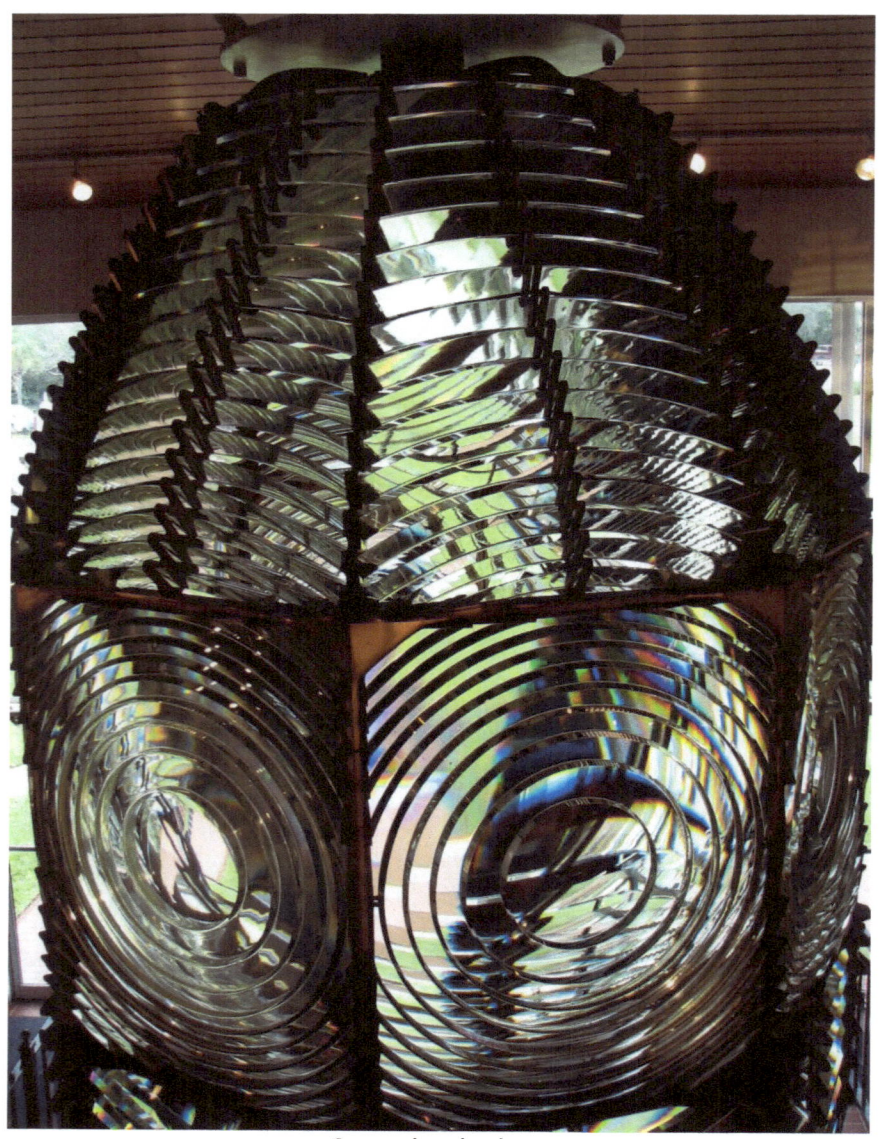

Second order lens

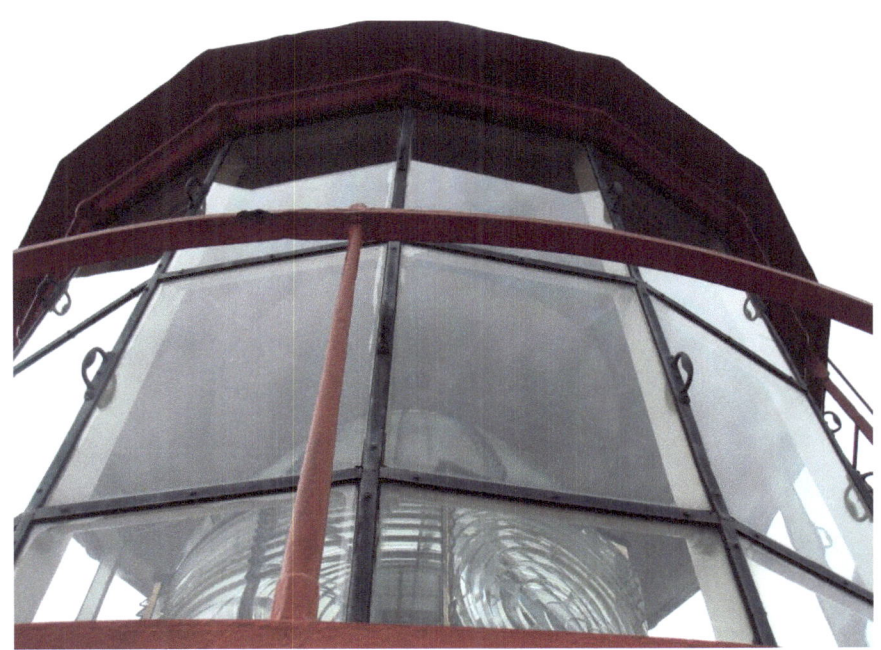

Juan Ponce de leon Lighthouse Light

First Lighthouse: Boston, MA (1716)
Oldest Lighthouse in Service: Sandy Hook, NJ (1764)
Newest Shoreside Lighthouse: Charleston, SC (1962)
Tallest Lighthouse: Cape Hatteras, NC (191 ft.)
Highest Lighthouse (above sea level): Cape Mendocino, CA (515 ft.)
First American-built West Coast Lighthouse: Alcatraz Lighthouse (1854)
First lighthouse to use electricity: Statue of Liberty (1886)
First Great Lakes lighthouses: Buffalo, NY & Erie, PA (1818)
Founding of the US Lighthouse Service—7 August 1789
US Lighthouse Service merged with the Coast Guard—7 July 1939

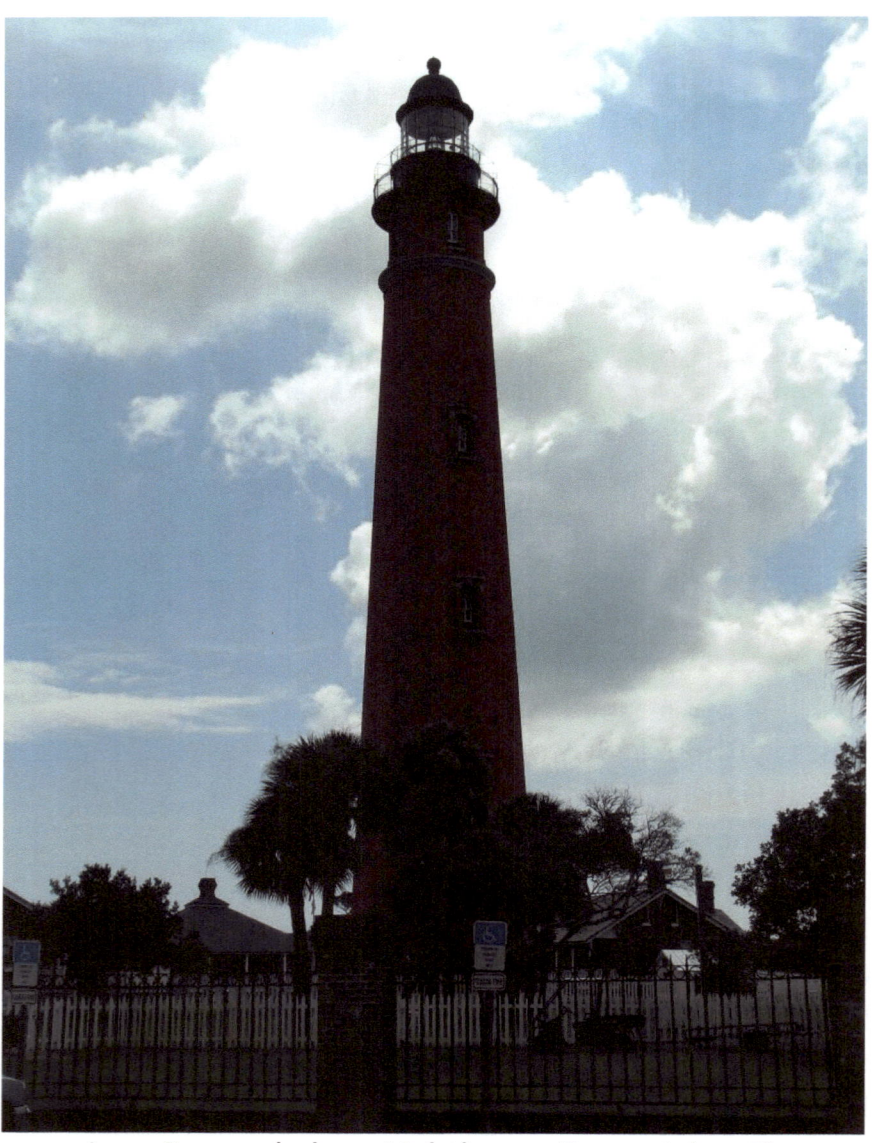

Juan Ponce de leon Lighthouse Ponce inlet, Fl.

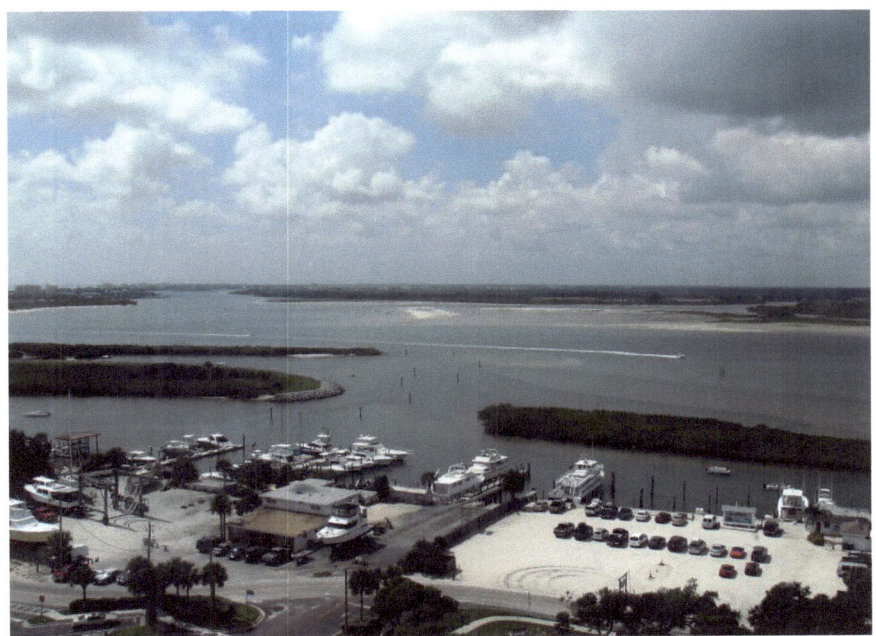

Above and below: The view from the top of the lighthouse.

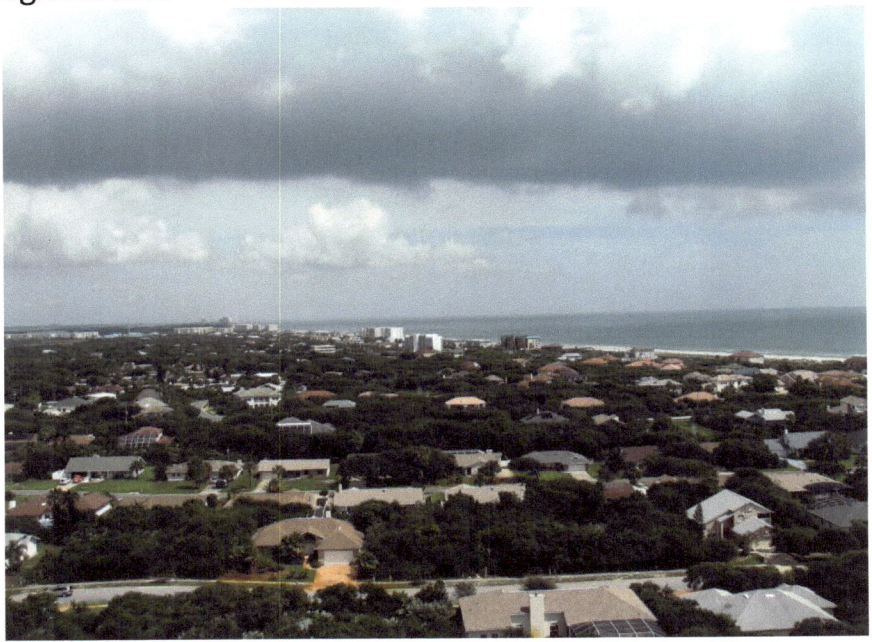

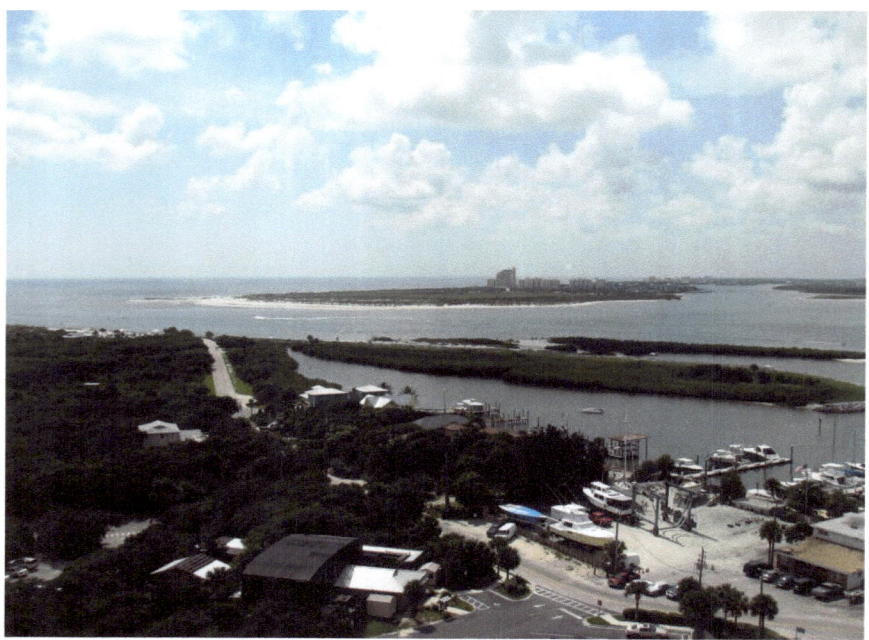

Above and below: The view from the top of the lighthouse.

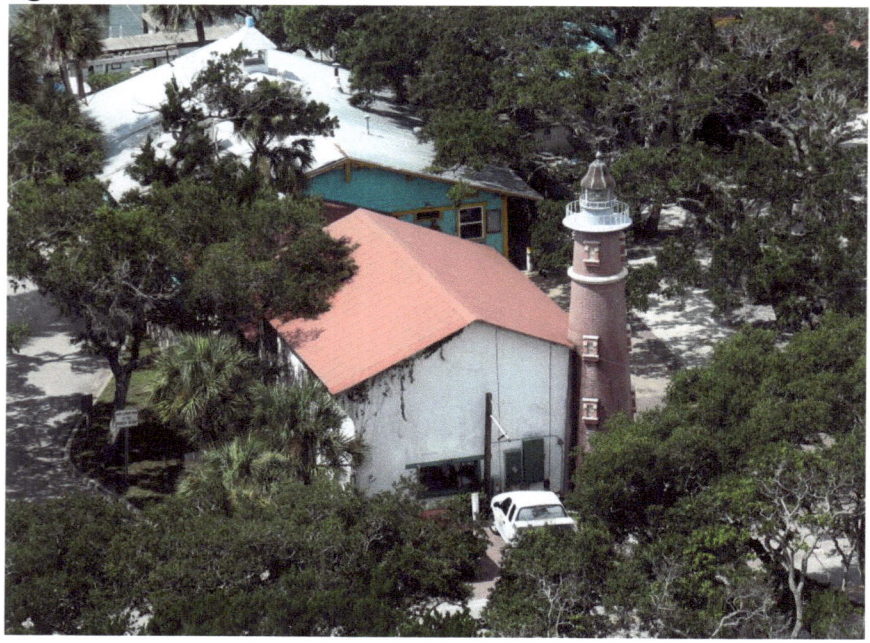

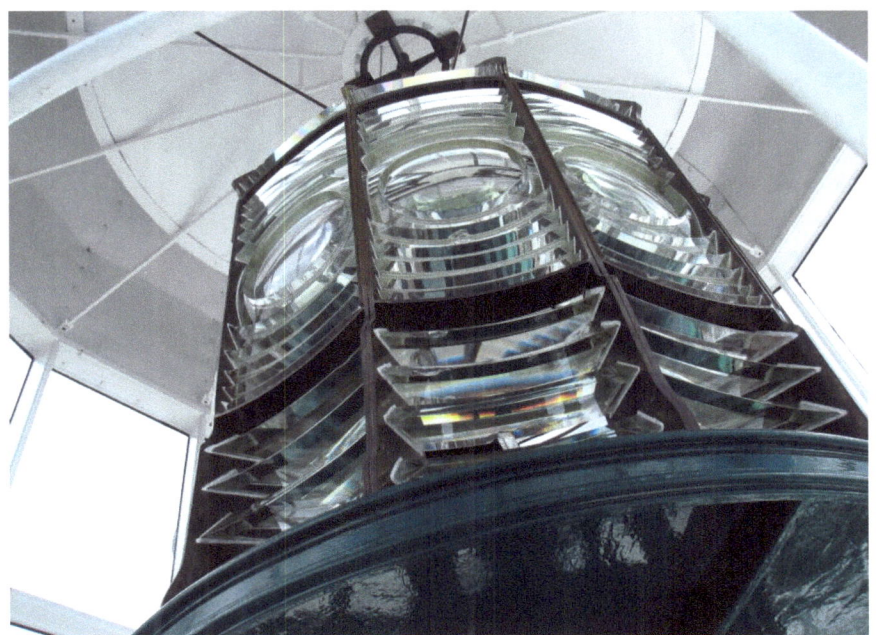

Light from Ponce de Leon Lighthouse.

The Ponce de Leon Inlet Lighthouse started as the Mosquito Inlet Lighthouse with the purchase of ten acres of land on March 21, 1883. The lighthouse tower design was based on Light-House Board standard plans with modifications made for the specific site. The lantern room was based on the design used at Florida's Fowey Rocks Lighthouse. Tragically, Chief Engineer Orville E. Babcock and three others drowned in the inlet when construction began in 1884. Despite this setback, the tower was completed three years later in 1887. The kerosene lamp had a first order fixed Fresnel lens that was first lit on November 1, 1887, by Keeper William Rowlinski. The new light could be seen from 20 miles at sea.

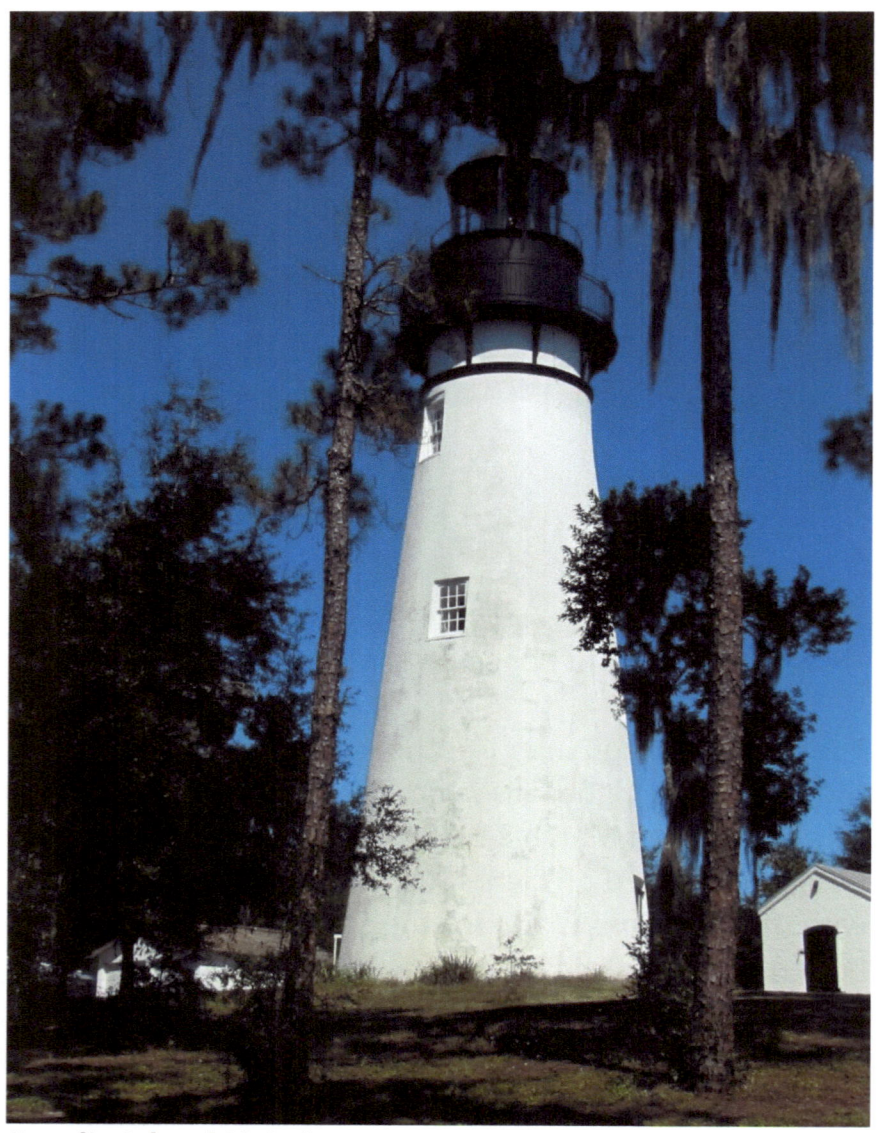

Amelia Island Lighthouse.
Amelia island was named in honor of Princess Amelia Hanover, daughter of England's King George II. Fernandina Beach was named after King Ferdinand VII of Spain.

According to local lore, since the arrival of the Europeans, eight flags have flown over Amelia Island, giving rise to the name "the Isle of 8 Flags." Three of these flags were from the brief reigns of the "Patriots of Amelia Island," Sir Gregor MacGregor, a pirate, the island's history can be summarized as "the French visited, the Spanish developed, the English named and the Americans tamed." In 1802, a resolution of the Georgia General Assembly gave jurisdiction of six acres on the southern tip of Cumberland Island to the U.S. Government for lighthouse purposes. At that time, this parcel was the southernmost site on the U.S. Atlantic coast, as Florida was back under Spanish rule, after the British left. It took eighteen years before Winslow Lewis built the lighthouse on Cumberland Island in 1820. In the interim, Congress had outlawed the importation of slaves in 1808. Given the proximity of Amelia Island to the Southern States, it soon became a major black market dealing in slaves and home to scores of smugglers, drunkards, and prostitutes. The United States eventually took control of the island in 1819. The lighthouse stood across the border, guiding vessels into St. Mary's River and along the Atlantic Coast. Changes in the channel made it so the light on Cumberland Island could no longer be seen when entering the river, and on July 7, 1838, Congress provided $7,500 for relocating the tower. Cumberland Lighthouse was dismantled brick by brick, shipped across the river, and reconstructed atop the highest spot on Amelia Island. Winslow Lewis returned to the area to oversee the relocation of the tower he had built eighteen years earlier.

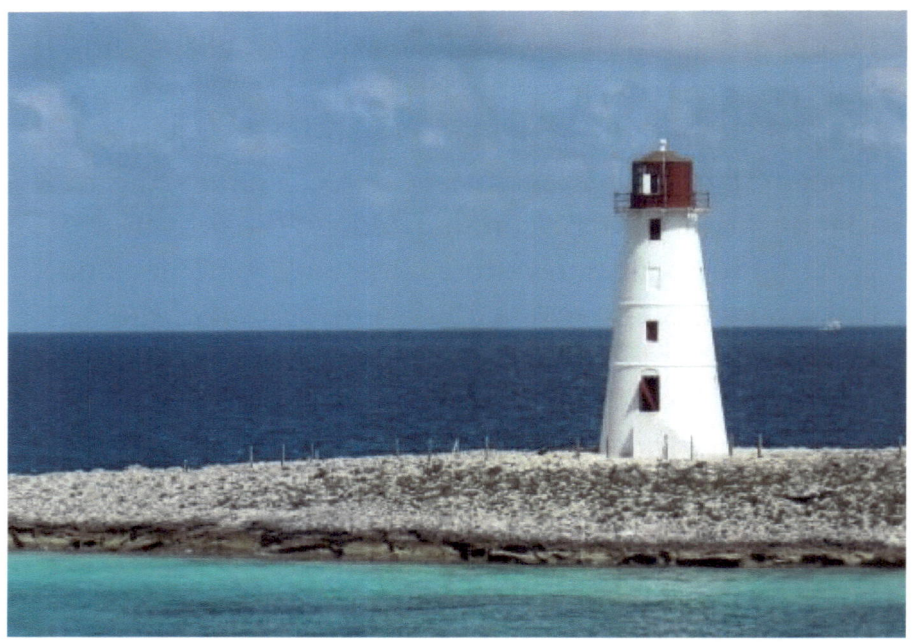

Above: **Hog Island Lighthouse, Bahamas**

Built in 1817, The Hog Island Lighthouse is located on the Western end of Paradise Island. The Paradise Island Lighthouse is an all-white lighthouse with a red top, that stands about the same size of a football field in height. The light it shines out to ships is usually white, but changes occasionally to warn when conditions are dangerous for entry. The Island was originally called Hog Island but the name was changed to make it more alluring to the rich and famous.

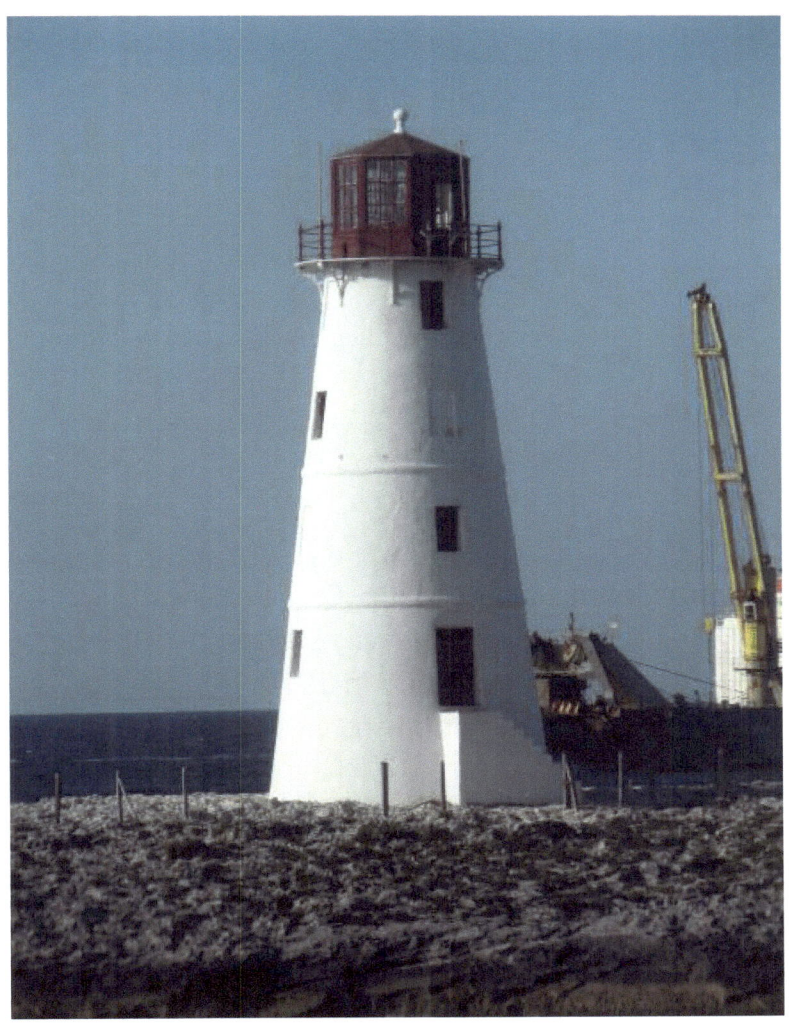

Hog Island Lighthouse.

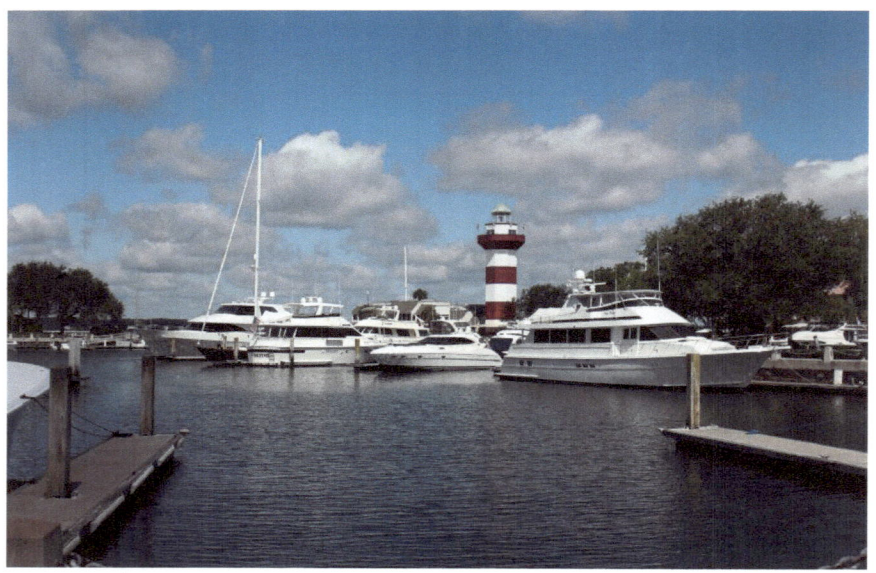

Harbor Town Lighthouse, S.C.

The Harbor Town lighthouse was started in 1969 by Charles Fraser and completed in 1970. It is privately owned but open to the public to visit.

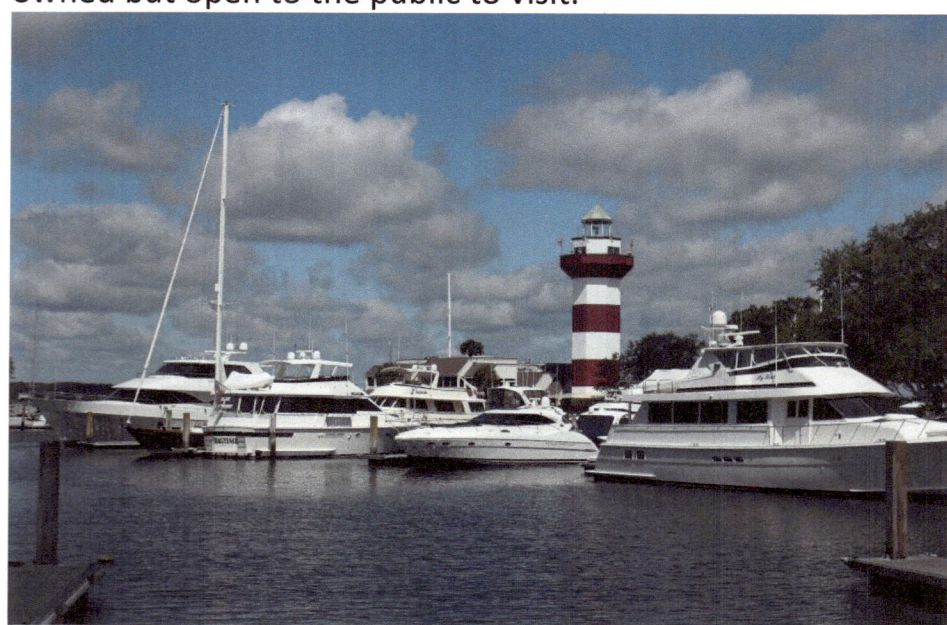

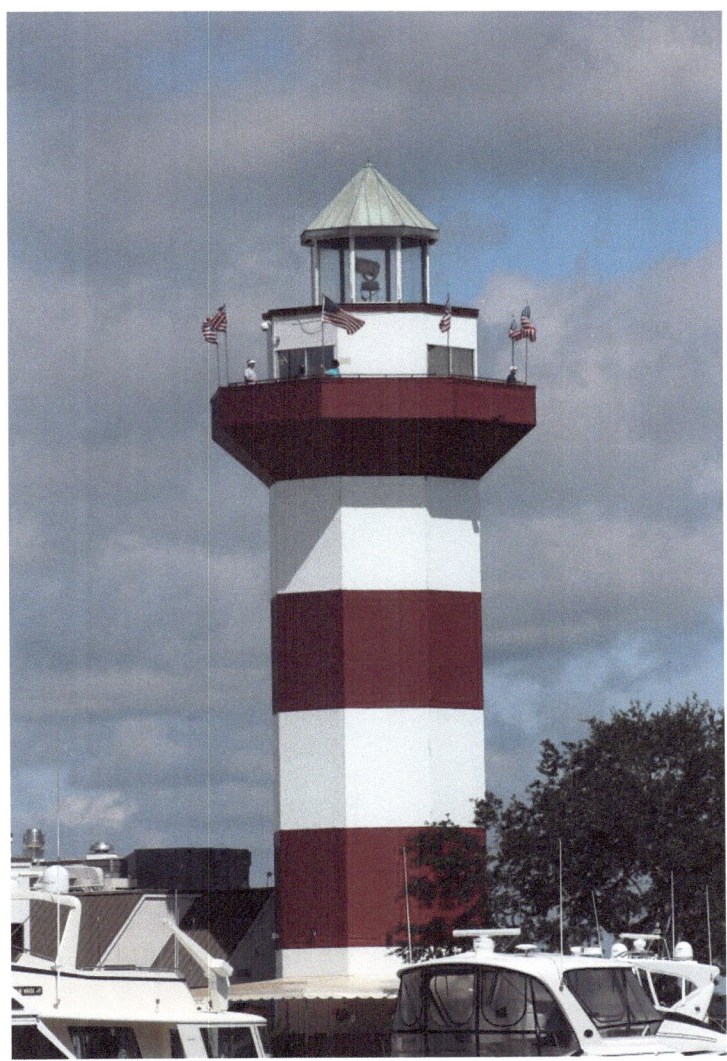

Above: **Harbor Town Lighthouse.**
It is a hexagonal column with a red observation deck or gallery below the lantern. The column is stucco on metal lath over plywood with a height of 90 feet. Its day mark is alternating red and white bands. It has a white light that flashes every 25 s.

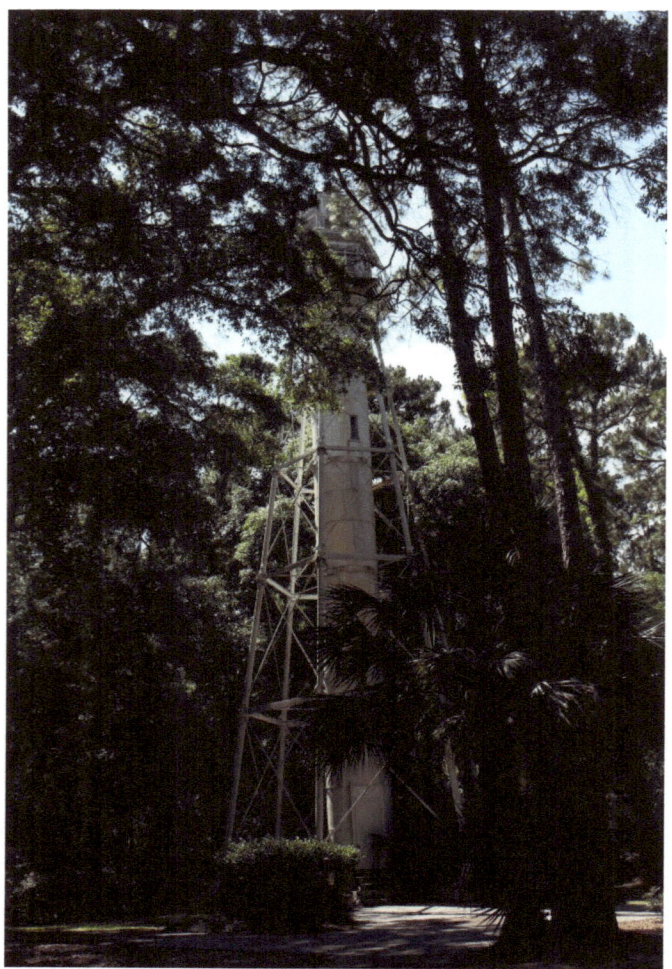

Above: **The Rear Lighthouse of Hilton Head Range Light Station.**

The **Rear Lighthouse of Hilton Head Range Light Station**, which is also called Leamington Lighthouse is an inactive light station on Hilton Head Island in Beaufort County, South Carolina. The light station was built by the U.S. Lighthouse Board in 1879 to 1880.

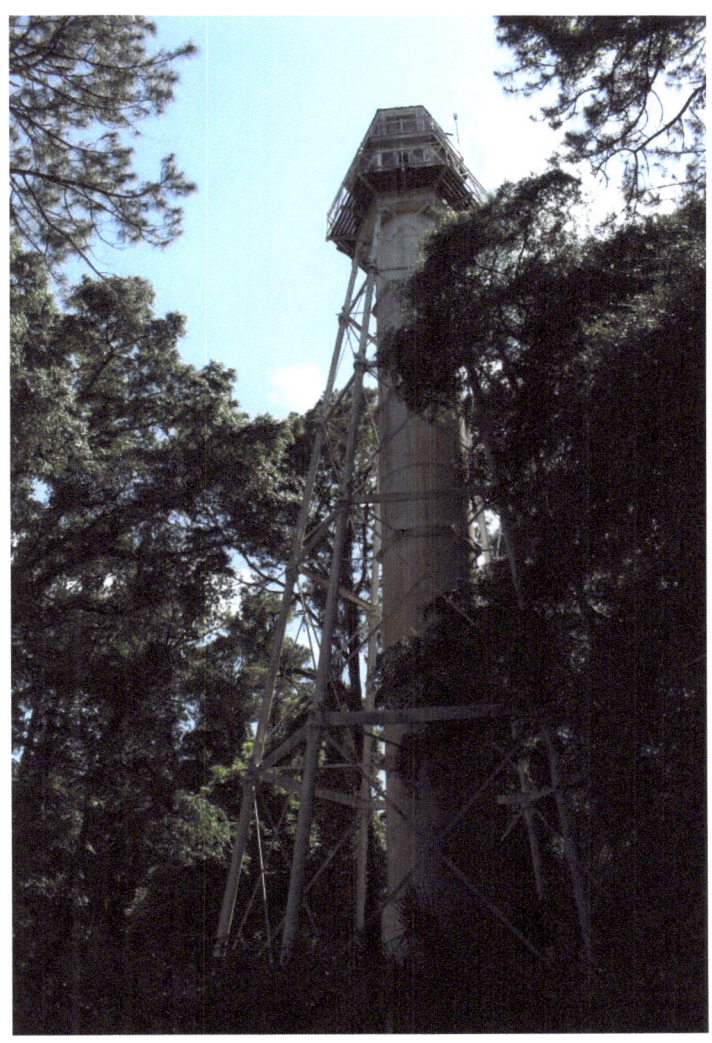

It is a cast-iron, skeleton tower on six concrete piers. The hexagonal base is 30 feet in diameter. There is a central, cylindrical stair tower with a spiral staircase. The hexagonal watch room and lantern has a wooden structure. The focal plane of the lantern is 87 feet above its base and 92 feet above sea level.

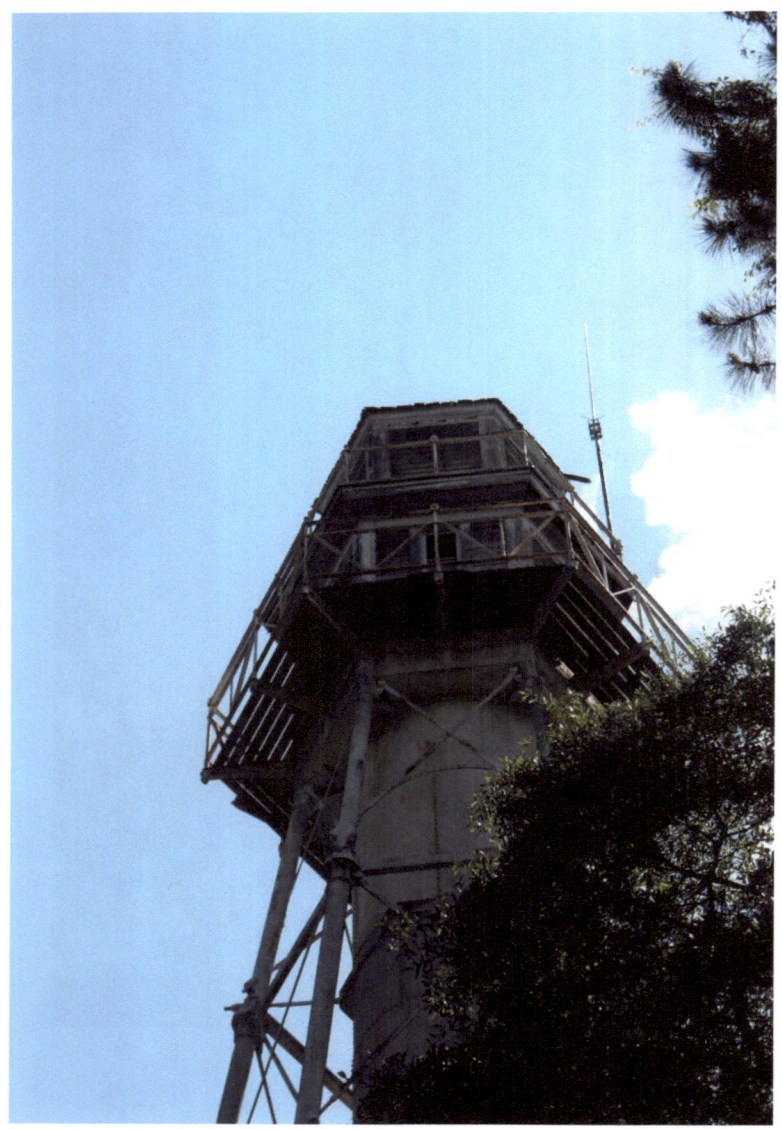

The tower was covered with wooden sheathing, which was later covered with sheet metal. This sheathing has been removed. The tower originally had Hain's oil lamps, which were replaced in 1893 with Funck-Heap lamps. The station was deactivated in 1932.

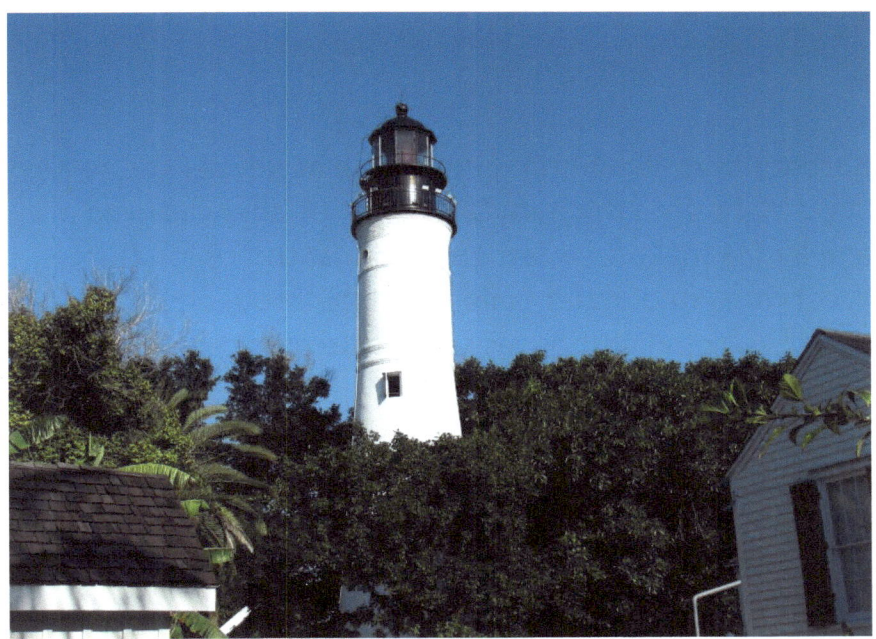

Above: **Key West Lighthouse**

The Key West lighthouse is located in Key West, Florida. The first Key West lighthouse was a 65-foot tower completed in 1825. It had 15 lamps in 15-inch reflectors. The first keeper, Michael Mabrity, died in 1832, and his widow, Barbara, became the lighthouse keeper, serving for 32 years. The Great Havana Hurricane of 1846 destroyed the lighthouse; the USS Morris, which was wrecked during the storm, reported "a white sand beach covers the spot where Key West Lighthouse stood". Barbara Mabrity survived, but fourteen people who had sought refuge in the lighthouse tower died, including seven members of her family. (The same hurricane destroyed the Sand Key Lighthouse, eight miles away, killing six people, including the keeper, Rebecca Flaherty, another widow of a previous keeper.)

Barbara Mabrity continued to serve as keeper of the Key West Light until the early 1860s, when she was fired at age 82 for making statements against the Union (Key West remained under Union control throughout the Civil War). As both lighthouses serving Key West had been destroyed in the 1846 hurricane, a ship, the Honey, was acquired and outfitted as a lightship to serve as the Sand Key Light until new lighthouses could be built. Due to efforts to reorganize the Lighthouse Board, Congress was slow to appropriate funds for the new lighthouses. The new tower for the Key West Light was completed in 1848. It was 50 feet tall with 13 lamps in 21-inch reflectors, and stood on ground about 15 feet above sea level. In 1858 the light received a third order Fresnel lens. In 1873 the lantern was replaced (it had been damaged by a hurricane in 1866), adding three feet to the height of the tower. The growth of trees and taller buildings in Key West began to obscure the light, and in 1894 the tower was raised twenty feet, placing the light about 100 feet above sea level. After the Coast Guard decommissioned the Key West Light in 1969, it was turned over to Monroe County, which in turn leased it to the Key West Arts and Historical Society. The society operates the lighthouse and its associated buildings as the Key West Light House and Keeper's Quarters Museum.

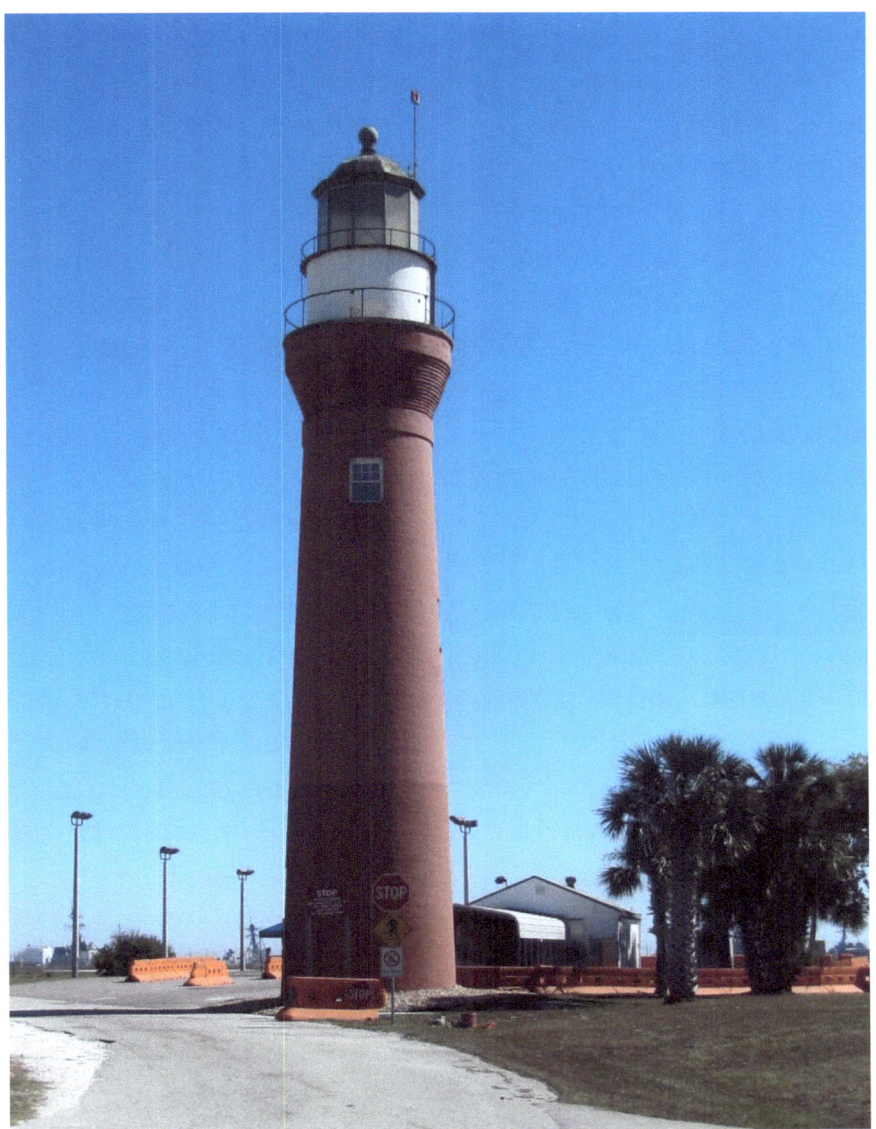

Above: **Jacksonville Lighthouse Florida**

The first St. Johns lighthouse was erected in 1830, after the U.S. purchase of Florida, and was funded by the U.S. Congress. However, it was built too close to the water and had to be demolished only three years later.

The second lighthouse was erected in 1835, about a mile upriver. However, view of the light from sea was blocked at times by shifting sand dunes, and by 1853 its foundation was so disturbed by erosion that plans were made to replace it. This structure was soon abandoned and taken over by the river. The present St. Johns River Light was erected in 1858 and made much taller and further from the waterline. During the American Civil War a Confederate soldier shot out the light to hamper Union ships attempting to locate the river. It was finally replaced on July 4, 1867. In 1887 authorities planned to heighten the tower another twelve feet. A study in the 20th century determined that this plan was never carried out, though the light station canopy was remodeled, and the present copper cupola was installed. In 1929, the St. Johns River Light was decommissioned after over 70 years of service. It was replaced by the St. Johns Lightship (LV-84), moored about 8 miles offshore from the river's mouth. In the 1940s the U.S. Navy acquired most of Mayport, including the area around the lighthouse, in order to establish Naval Station Mayport. The Navy demolished an attached one-story building and raised the grade of the surrounding land by about seven feet. As such the original door is buried and the tower is only accessible via a window eight feet off the ground. In 1954 the modern St. Johns Light was built to replace the lightship. It currently stands at 85 feet tall, with a red brick tower, slate stairs and balcony, and a white watch room topped by a copper cupola.

Lighthouse

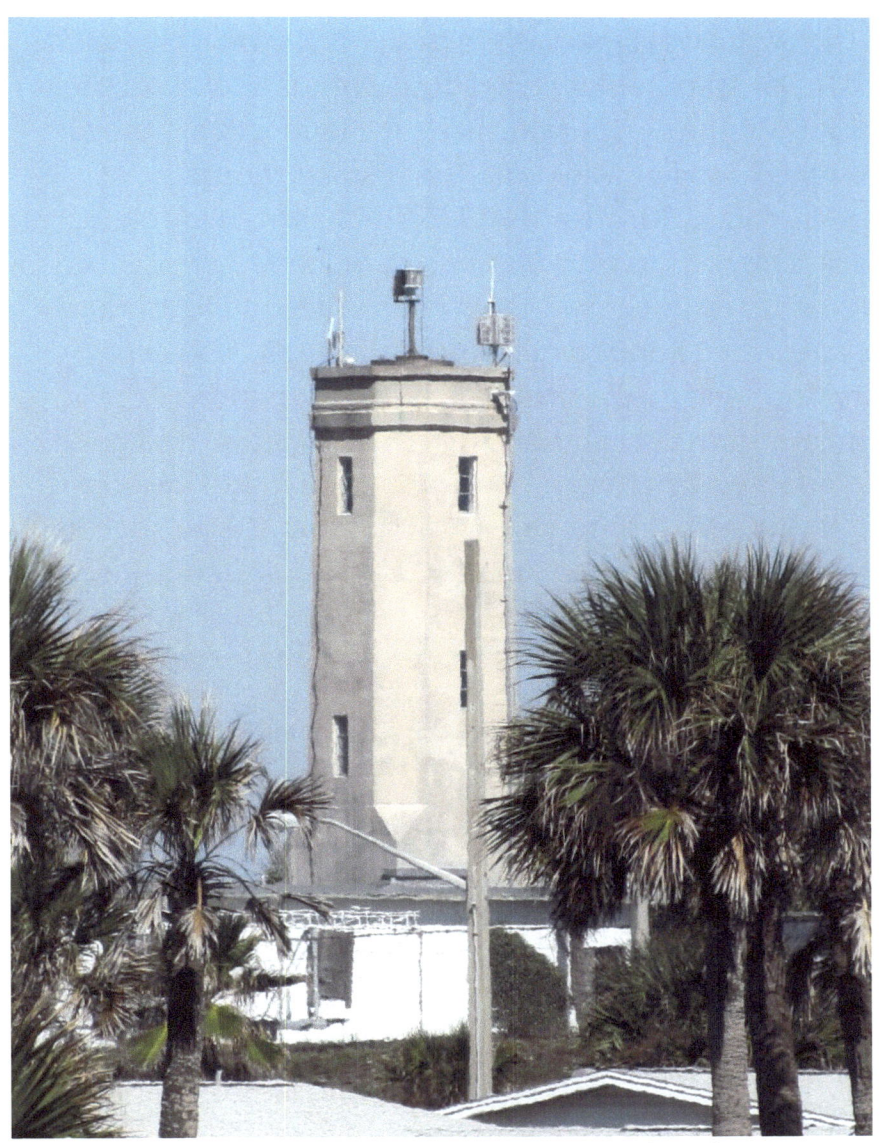

Above: **Jacksonville Lighthouse Florida**

The St. Johns Light was erected in 1954 on the grounds of Naval Station Mayport, about 3/4 mile south of the mouth of the St. Johns River. It is the fourth lighthouse to have stood at Mayport. The first lighthouse was erected in 1830, after the U.S. purchase of Florida, but it was built too close to the water and had to be demolished just three years later. A second lighthouse was erected about a mile upriver in 1835. However, shifting sand dunes often made the light difficult to discern from sea, and by 1853 its foundation had been so affected by erosion that plans were made to replace it. It was abandoned, but its ruins could still be seen in the early 20th century. In 1858 the Old St. Johns River Light was erected. In order to avoid the problems of its predecessors, it was constructed away from the shoreline and was substantially taller. It was in service for over 70 years until finally being decommissioned in 1929. That year it was replaced by the St. Johns Lightship (LV-84), moored about eight miles offshore of the river's mouth. The oldest surviving building in Mayport, the Old St. Johns River Lighthouse was placed on the National Register of Historic Places in 1976 and restored in 1980. In 1954 the current St. Johns Light was built to replace the lightship. It was automated in 1967. The structure is made of concrete, poured in one continuous operation. It has never had a traditional lantern, but had an airway-beacon style light from the beginning until 1998 when it was replaced by a Vega VRB-25 system. The structure is 64 feet tall and can be seen for 22 miles.

Lighthouse

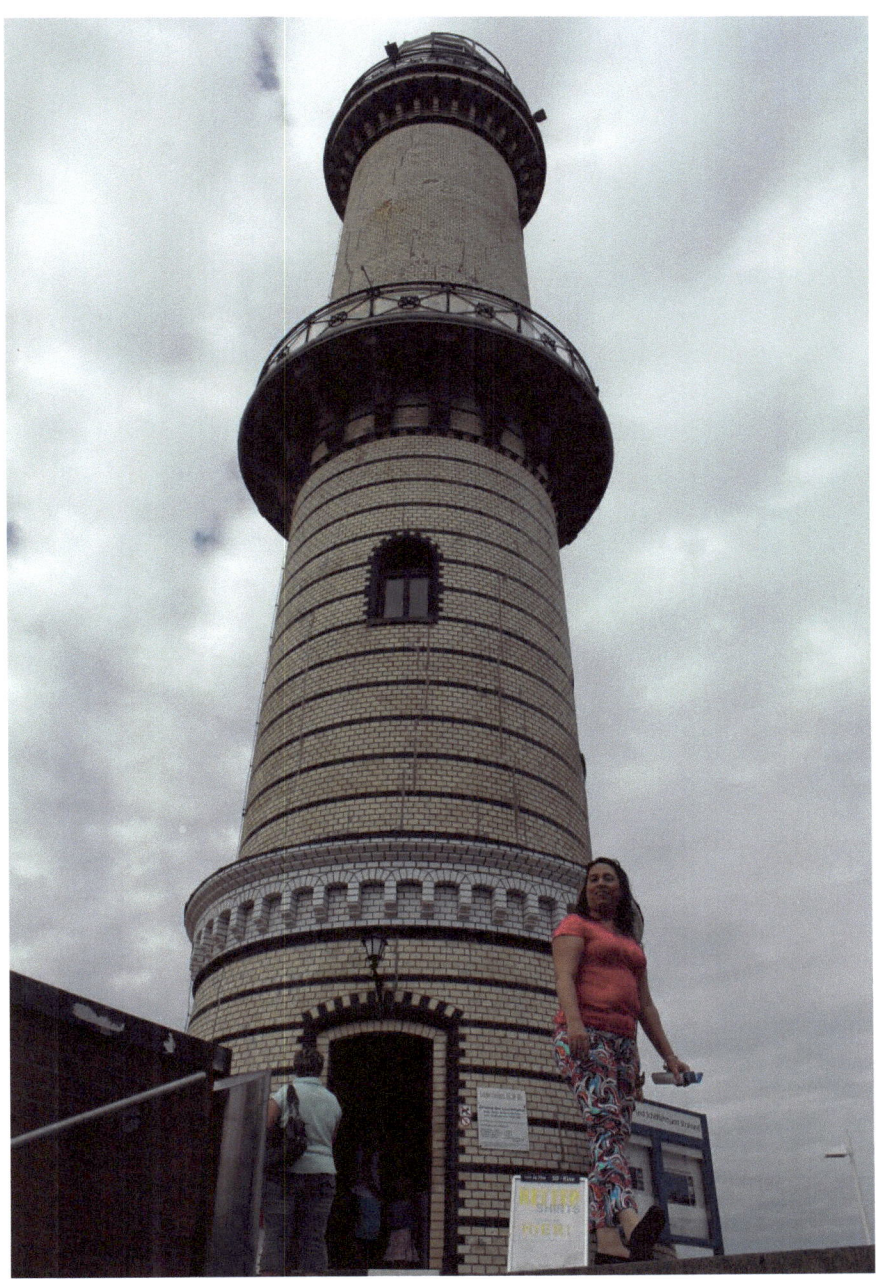

Above: **Lighthouse in Warnemunde, Germany**

Willie Ortiz

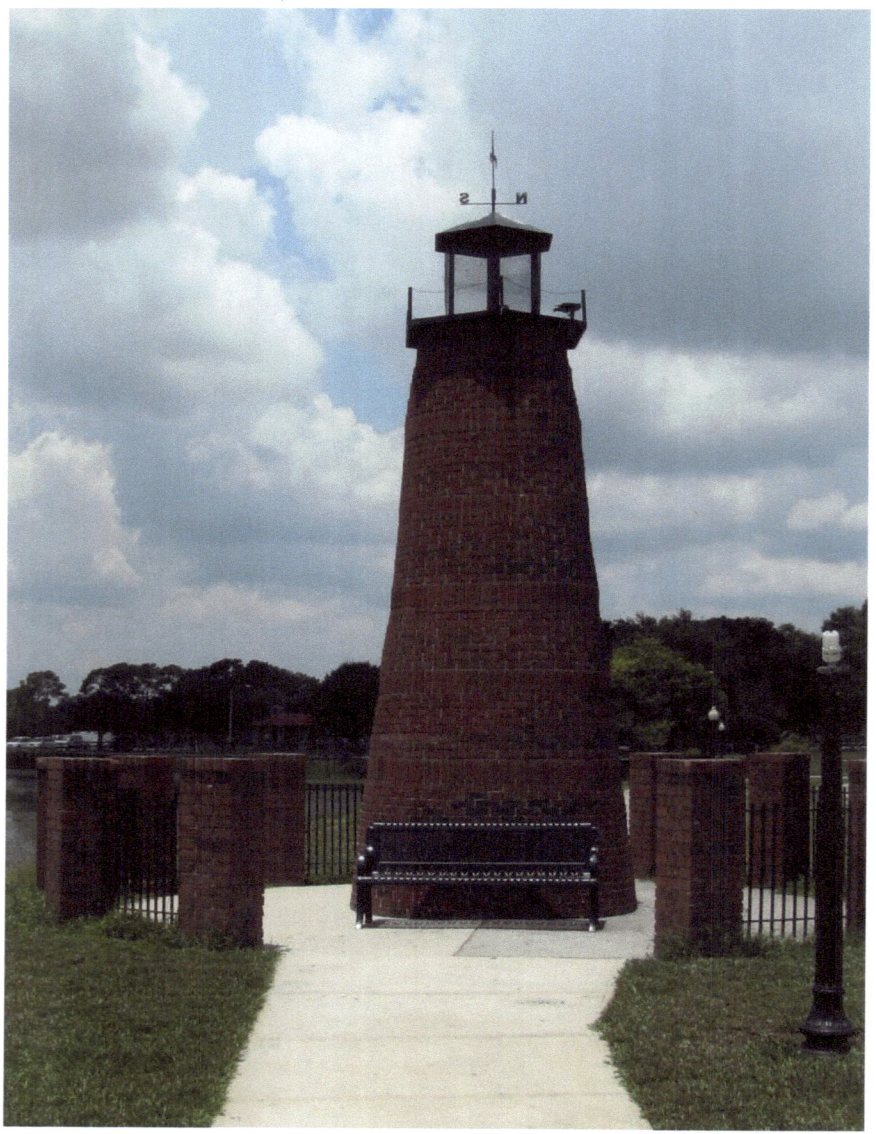

Above: **Kissimmee Lighthouse Florida**

Built in 1999. It is active (privately maintained) with a focal plane 25 ft. The Lighthouse has a rotating white light. It has a 22 ft. round red brick tower with lantern and gallery. The lantern is painted black. This light is on Lake Tohopekaliga, a large lake in Osceola County linked by canals to several other area lakes. It is located at the end of an artificial peninsula extending into the lake in Kissimmee's Lakefront Park, about 1/4 mi northeast of the marina. The Site is open but the tower is closed. It is owned by the City of Kissimmee.

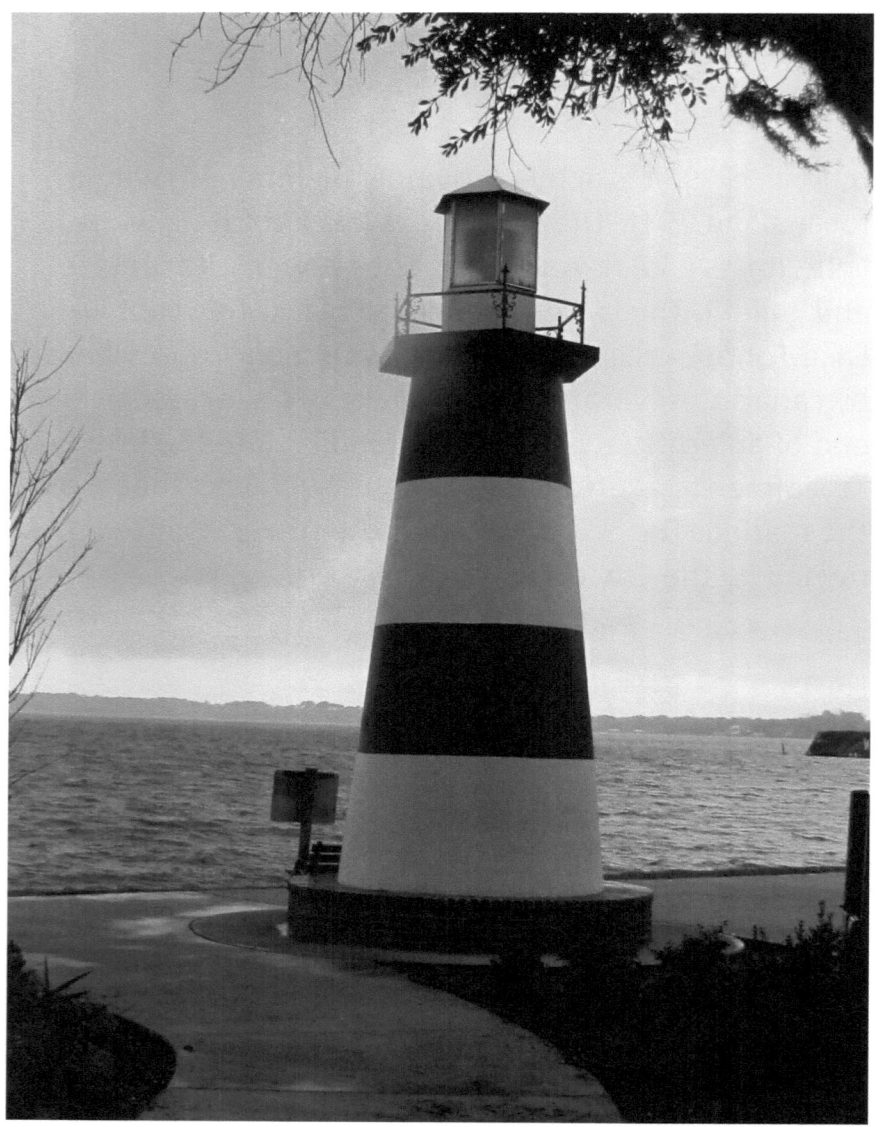

Above: **Mount Dora Lighthouse Florida**

Built in 1988 it is an active lighthouse (though privately maintained). It has a flashing red light. It is a 35 ft. stucco-covered brick tower with hexagonal lantern and gallery, painted with horizontal red and white bands. The lighthouse was built with citizen contributions. It is located on Grantham Point, in Gilbert Park at the south end of Tremain St. on the northeast side of Lake Dora in Mount Dora, about 25 miles northwest of Orlando. The site is open but the tower is closed. It is owned by the City of Mount Dora.

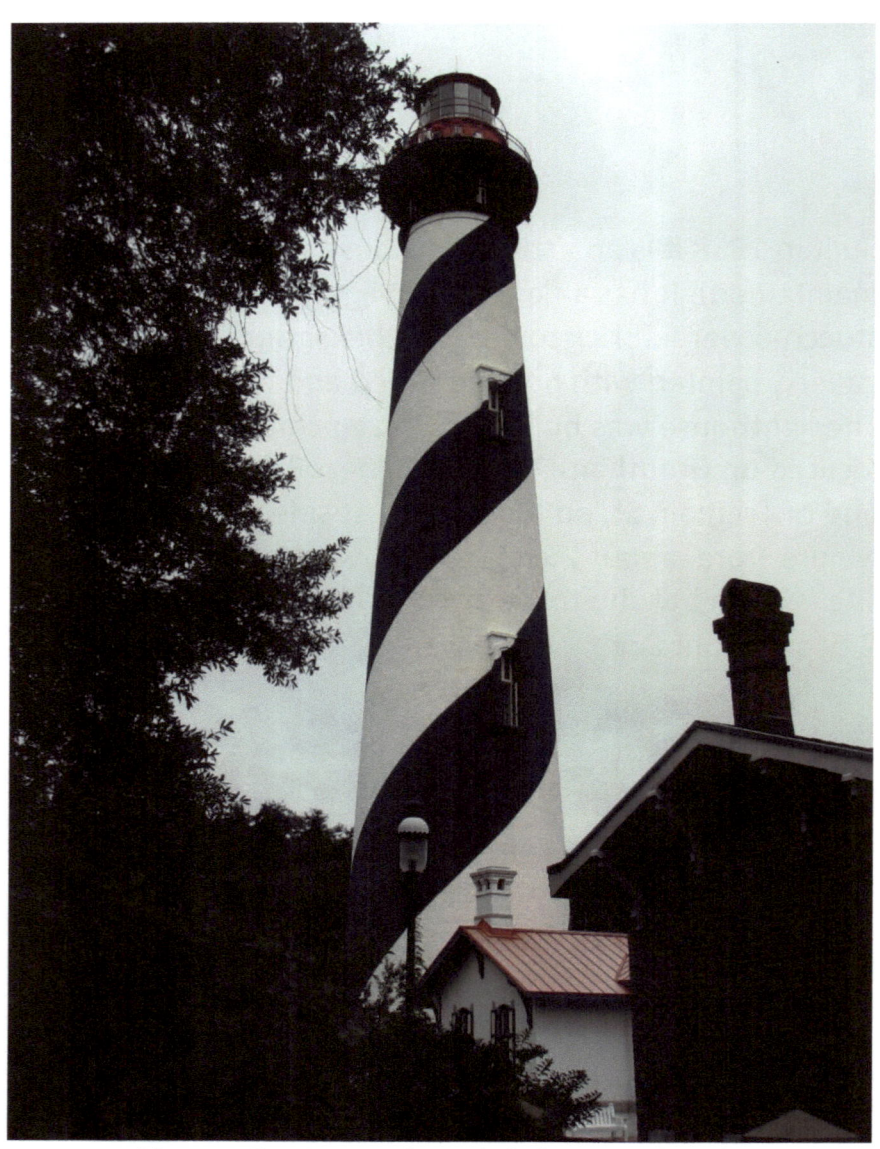

Above: **St. Augustine Lighthouse Florida**

Lighthouse

St. Augustine was the site of the first lighthouse established in Florida by the new, territorial, American Government in 1824. According to some archival records and maps, this "official" American lighthouse was placed on the site of an earlier watchtower built by the Spanish as early as the late 16th century. A map of St. Augustine made by Baptista Boazio in 1589, depicting Sir Francis Drake's attack on the city, shows an early wooden watchtower near the Spanish structure, which was described as a "beacon" in Drake's account. By 1737, Spanish authorities built a more permanent tower from coquina taken from a nearby quarry on the island. Archival records are inconclusive as to whether the Spanish used the coquina tower as a lighthouse, but it seems likely, given the levels of maritime trade by that time. The structure was regularly referred to as a "lighthouse" in documents dating to the British Period beginning in 1763. In 1783, the Spanish once again took control of St. Augustine, and once again the lighthouse was improved. Swiss-Canadian engineer and marine surveyor Joseph Frederick Wallet DesBarres marks a coquina "Light House" on Anastasia Island in his 1780 engraving, "A Plan of the Harbor of St. Augustin". Jacques-Nicolas Bellin Royal French Hydrographer, refers to the coquina tower as a "Batise" in Volume I of Petit Atlas Maritime. The accuracy of these scholars is debated still; DesBarres work includes some obvious errors, but Belline is considered highly qualified. His work provides an important reference to St. Augustine's geography and landmarks in 1764. Facing erosion and a changing coastline, the old tower crashed into the sea in 1880, but not before a new lighthouse was lit. Today, the tower ruins are a submerged archaeological site whose smooth stones may still be seen at low tide. Early lamps in the first tower burned lard oil. Multiple lamps with silver reflectors were replaced by a fourth order Fresnel lens in 1855, greatly improving the lighthouse's range and eliminating some maintenance issues.

At the beginning of the Civil War, future mayor Paul Arnau, a local Minorcan harbor master, along with the lightkeeper, a woman named Maria De Los Delores Mestre, removed the lens from the

old lighthouse and hid it, in order to block Union shipping lanes. The lens and clock works were recovered after Arnau was held captive on a ship off-shore and forced to reveal their location. By 1870, beach erosion was threatening the first lighthouse. Construction on a new light tower began in 1871 during Florida's reconstruction period. In the meantime, a jetty of coquina and brush was built to protect the old tower. A trolley track brought building supplies from the ships at the dock. The new tower was completed in 1874, and put into service with a new first order Fresnel lens. It was lit for the first time in October by keeper William Russell. Russell was the first lighthouse keeper in the new tower, and the only keeper to have worked both towers.

For 20 years, the site was manned by head-keeper William A. Harn of Philadelphia. Major Harn was a Union war hero who had commanded his own battery at the Battle of Gettysburg. With his wife, Kate Skillen Harn, of Maine, he had six daughters. The family was known for serving lemonade out on the porches of the keepers' house, which was constructed as a Victorian duplex during Harn's tenure. In 1885, after many experiments with different types of oils, the lamp was converted from lard oil to kerosene. On August 31, 1886, the Charleston earthquake caused the tower to "sway violently", according to the keeper's log, but there was no recorded damage. In 1907, indoor plumbing reached the light station, followed by electricity in the keeper's quarters in 1925. The light itself was electrified in 1936, and automated in 1955. During World War II, Coast Guard men and women trained in St. Augustine, and used the lighthouse as a lookout post for enemy ships and submarines which frequented the coastline. In 1955.Due to the automation, positions for three keepers slowly dwindled down to two and then one. No longer housing lighthouse families by the 1960s, the keepers' house was rented to local residents. Eventually it was declared surplus, and St. Johns County bought it in 1970. In that year the house suffered a devastating fire at the hands of an unknown arsonist.

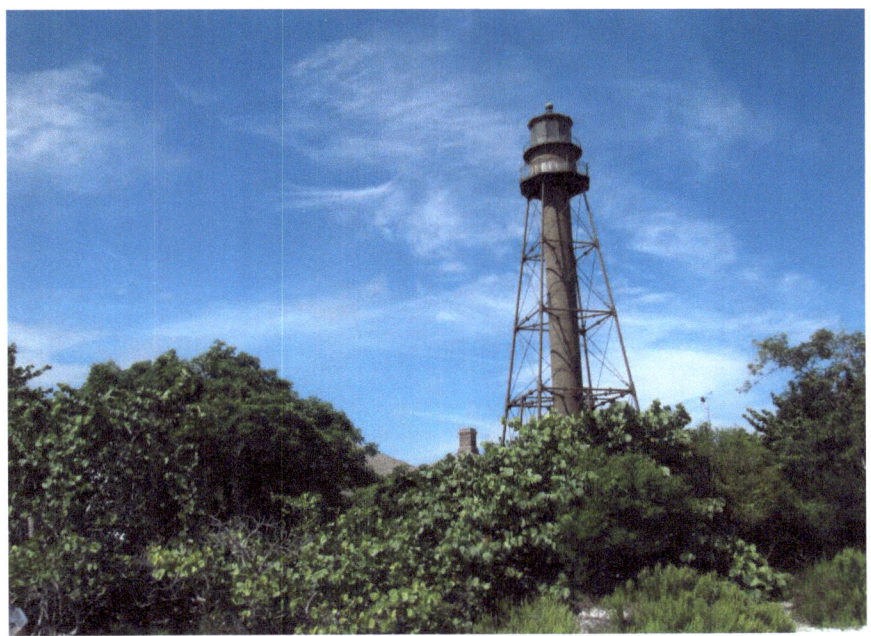

Above: **Sanibel Island, FL**

Residents of Sanibel Island first petitioned for a lighthouse in 1833, but no action was taken. In 1856 the Lighthouse Board recommended a lighthouse on Sanibel Island, but Congress took no action. In 1877 government workers surveyed the eastern end of the island and reserved it for a lighthouse. Congress finally appropriated funds for a lighthouse in 1883. The foundation for the new lighthouse was completed in early 1884, but the ship bringing ironwork for the tower sank two miles from Sanibel Island. A crew of hard-hat divers from Key West recovered all but two of the pieces for the tower. Punta Rassa became an important port in the 1830s and remained so up to the Spanish–American War. It was primarily used to ship cattle from Florida to Cuba. Until the railroads reached the area in the 1880s, ranchers drove their cattle from open ranges in central Florida to Punta Rassa for shipment to Cuba. The lighthouse was placed on the National Register of Historic Places in 1974. The City of Sanibel now owns the Point Ybel tract and structures, although the tower is still operational under U.S. Coast Guard control.

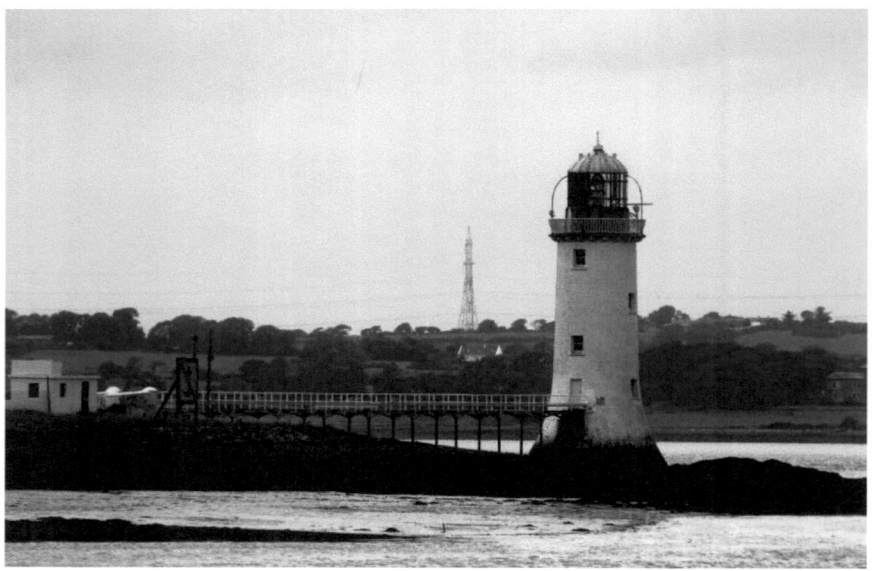

Tarbert Island Lighthouse, Ireland
Built in 1834, The lighthouse is active. Its focal plane is 60 ft. white light, 2 s on, 2 s off; A red light is shown in a narrow sector westward over Bowline Rock. 74 ft. round limestone tower with lantern and gallery, painted white. A spidery cast iron bridge which was built about 1840, connects the tower to shore. The keeper's house was apparently demolished. The listed focal plane height seems too low. The lighthouse is now dwarfed by the huge smokestacks of an electric power generating plant built immediately behind. Long maintained by CIL (commission of Irelands lighthouses), the lighthouse was formally transferred to the Limerick Harbor Commissioners in 1981. However, CIL has a buoy depot nearby and the same attendant manages both facilities. Located on the south (County Kerry) side of the Shannon estuary just north of Tarbert. The lighthouse is operated by the Shannon Foynes Port Company.

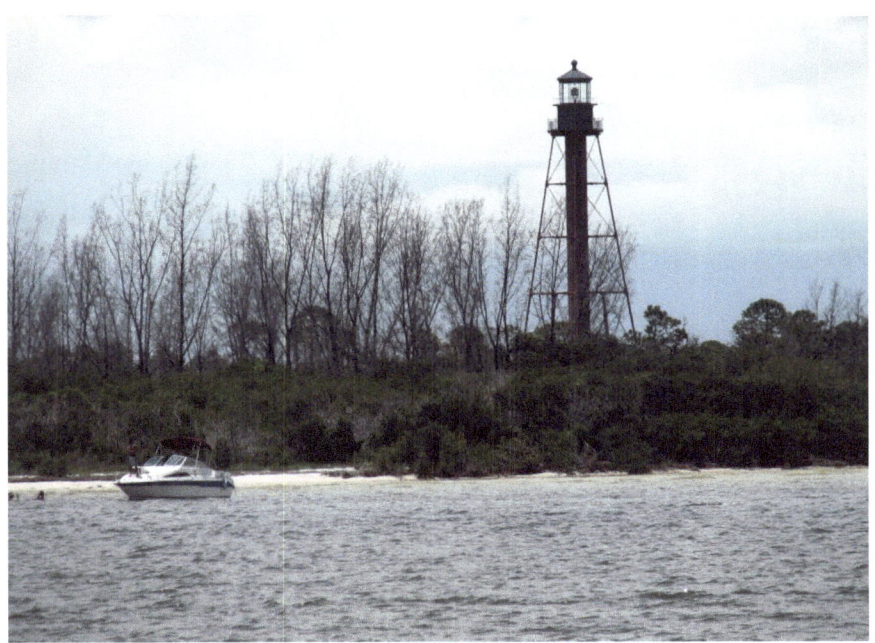

Above: **Anclote Lighthouse Tarpon Springs Fl.**

Construction on the lighthouse began in June 1887, later than the required date of March 1, 1886 because the barge carrying the metal work had sunk and the pieces had to be recovered. The lighthouse was completed and first lit on September 15, 1887. The first lens in the tower was a third-order Fresnel lighted by a kerosene walkways and the wharf were also built around this time.

ABOUT THE AUTHOR

Willie Ortiz is an avid wildlife, nature and travel photographer. He has traveled the world to view and photograph animals in their natural habitat. When the natural habitat is almost impossible, Willie is a patron of animal rehabilitation and education centers. Willie's photography can be seen on the Your Shot by National Geographic and Flickr. 'Animals of Belize' Willie's first book truly shows the passion he has for protecting wildlife through education. Willie Ortiz is originally from the Bronx, and currently presides on the Treasure Coast of Florida.

www.ingramcontent.com/pod-product-compliance
Lightning Source LLC
Chambersburg PA
CBHW040812200526
45159CB00022B/477

Copyright 2016 by
Sound Impressions LLC

SIP-016

All Rights Reserved. No part of this publication may be reproduced or transmitted in any form or by any means, electronic or mechanical, including photocopy, recording, or and other information storage and retrieval system, without the written permission of the publisher.

For information about custom editions, special sales, signings, premium, and corporate purchases please contact:

Publisher: Sound Impressions

Address: Sound Impressions
 Attn: Publishing
 PO Box 754
 Boonton, NJ 07005

Phone: (973) – 263 – 0521

Web: http://www.soundimp.net

Produced By: Jason Koba

Photographs by: Eric Shaffer

Model / Wrestler / Subject: Niya